Historic England

Central London

Simon McNeill-Ritchie

AMBERLEY

First published 2018

Amberley Publishing
The Hill, Stroud, Gloucestershire, GL5 4EP
www.amberley-books.com

The publisher is grateful to staff at Historic England
who gave their time to review this book.

All contents remain the responsibility of the publisher.

ISBN 978 1 4456 8175 7 (print)
ISBN 978 1 4456 8176 4 (ebook)

British Library Cataloguing in Publication Data.
A catalogue record for this book is available from the
British Library.

Origination by Amberley Publishing.
Printed in Great Britain.

Contents

Introduction 5

Westminster 8

Whitehall 17

The Mall 24

Kensington and Hyde Park 29

Oxford Street to Covent Garden 38

Regent's Park and Fitzrovia 52

City of London 57

East London 75

Greenwich and Bermondsey 78

Southwark 83

Lambeth 89

About the Archive 96

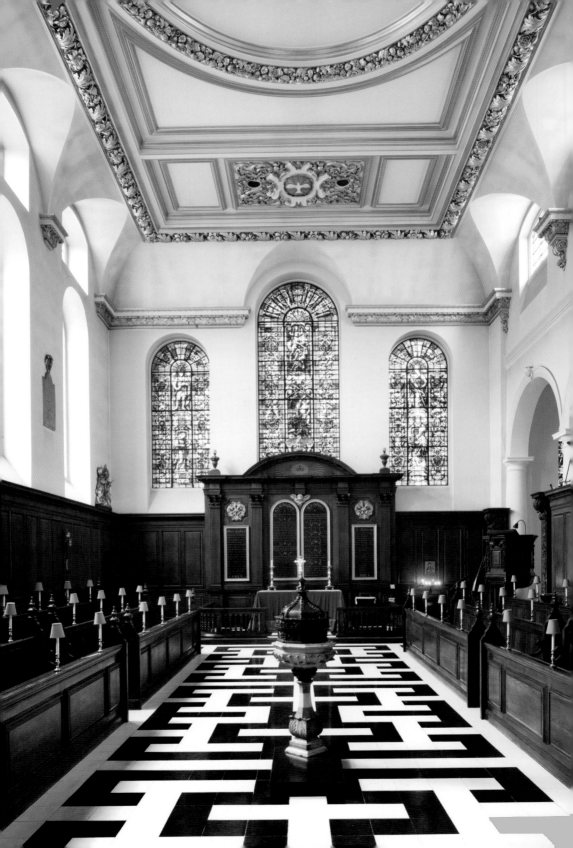

Introduction

Is London the greatest capital city in the world? Founded 2,000 years ago, it became in Shakespeare's day the stage for British and European history. By the nineteenth century it was the most populous city in the world and the nexus of an empire spanning one quarter of the globe. Today, London remains a global political and financial centre, a crucible for new technology and the stage for a vibrant cultural scene that draws millions of visitors every day.

The remains of structures dating back to the Bronze Age and even earlier have been found around Vauxhall, but it was the Romans who, shortly after their invasion of Britain in AD 43, recognised the strategic position of a bridge across a narrow section of the River Thames. There they established Londinium, derived from the Celtic word 'londinios' meaning the place of the 'bold one'. It was destroyed by Queen Boudica and the Iceni around AD 60, but the Romans quickly rebuilt it as a Roman town, complete with an amphitheatre, fort, temples, baths and, at more than 152 metres (500 feet) long and 21 metres (70 feet) high, the largest basilica north of the Alps. By the second century Londinium had replaced Colchester as the Roman capital of Britannia. As part of these changes the Romans built the defensive London Wall, 6 metres (20 feet) high, 2.5 metres (8.2 feet) thick and 3 kilometres (1.9 miles) long, to protect the landward side of the city to the north. Six of the traditional seven city gates of London are of Roman origin (Aldersgate, Aldgate, Bishopsgate, Cripplegate, Ludgate and Newgate), the exception being the medieval Moorgate. The remains of the wall can still be seen today and it continues to mark the approximate perimeter of 'the City', London's historic core and present-day financial district.

After the Roman occupation of Britannia ended in AD 410, the area to the west between the City and Trafalgar Square was settled by the Middle Saxons (hence Middlesex) and eventually grew into an important trading centre known as Lundenwic. From 830 it was increasingly subject to attacks by the Vikings, who sacked it in 842 and again in 851, and occupied it until 886, when it was captured by the forces of King Alfred the Great of Wessex. Alfred moved the settlement back within the old Roman walls, which were repaired and the defensive ditch recut. The Saxon settlement of Lundenwic became known as the Ealdwic or 'old settlement', the name of which is preserved today as Aldwych. Although the traditional West Saxon capital was Winchester, London's size and commercial wealth made it an increasingly important focus for government activity: King Athelstan held many meetings of the witan there, while King Æthelred the Unready issued the Laws of London in 978. It also attracted unwelcome attention once again from the Vikings, who resumed their raids at the end of the millennium and finally succeeded in recapturing the town (and the country) in 1013. Saxon rule was restored in 1043 with the crowning of Edward the Confessor at Winchester. He founded Westminster Abbey and spent much of his time in London.

After Edward died without an heir in 1066, William, Duke of Normandy, defeated the English at the Battle of Hastings and then occupied London, where he

had himself crowned king in Westminster Abbey. To secure his conquest, William rebuilt the Tower of London in stone – with the first keep made from this material in England – and issued a charter in 1067 confirming London's existing rights, privileges and laws. London's de facto status as England's capital was further confirmed in 1097, when William's son, William Rufus, began the construction of Westminster Hall, which later became the site of the Palace of Westminster. The following century, construction began on the most famous incarnation of London Bridge (completed in 1209), which was to last 600 years and remain the only bridge across the River Thames until 1739.

London's expansion beyond the boundaries of the City began in earnest during the seventeenth century. The theatre, which had already been made popular through playwrights such as William Shakespeare, was complemented during the reign of Charles I by elaborate masques at the royal court and the Inns of Court. Country landowners and their families now increasingly came up to the West End for the 'London season'. This migration away from the old City was given further impetus later that century by two natural disasters. In 1665, Britain suffered its last major outbreak of plague, in which an estimated 100,000 people – nearly one quarter of London's population – perished in just eighteen months. The Great Plague was immediately followed by the Great Fire of London, which broke out at a bakery in Pudding Lane in the southern part of the City and burned for three days. Astonishingly, the fire took just sixteen lives, but it destroyed around 60 per cent of the buildings, including Old St Paul's Cathedral. Within a few days of the fire, plans were presented to the king for the rebuilding of the City, and Christopher Wren's new baroque cathedral, completed in 1711, would dominate the skyline of London for more than a century. Nevertheless, London now spread rapidly beyond its historical limits. Many aristocratic residents preferred to take houses in the West End and in new districts such as Mayfair, close to the main royal residences. More bridges over the Thames encouraged development in South London, while to the east of the City, the Port of London expanded downstream.

By the first half of the nineteenth century London had grown into the world's largest city, with a population of 1 million in 1800 and rising to 6.7 million by the end of the century. Now the capital city not just of the British Isles but the largest empire ever known, London became a global political, financial and trading centre without equal. The Great Exhibition of 1851 in the Crystal Palace showcased Britain's industrial leadership and attracted 6 million visitors from across the world. Many London landmarks date from this century, too, including Big Ben and the Houses of Parliament, Trafalgar Square and Nelson's Column, the Royal Albert Hall and Tower Bridge, as do some of its more famous museums and public parks. The capital was further transformed by the coming of the railways. The first line from London Bridge to Greenwich opened in 1836, and within a few years the great rail termini of Euston, Paddington, Waterloo and King's Cross connected London to every corner of Britain. The first lines of the London Underground were laid in 1863, the same year that St Pancras station was built. A growing network of metropolitan railways led to the development

of suburbs around London into which the wealthier white-collar workers could escape, leaving the poor to the inner-city slums immortalised by Charles Dickens.

London entered the twentieth century at the height of its power. In the ensuing decades, the spread of the suburbs continued beyond the boundaries of London into the neighbouring counties, facilitated by the expansion of the railway network and the Underground system, but also by the rise in car ownership. In 1939, just as the country entered the Second World War, the population of London reached an all-time peak of 8.6 million. In 1948, just three years after the end of the Second World War, London staged the Olympic Games for a second time. The Festival of Britain in 1951 on the centenary of the Great Exhibition triggered renewed optimism and rebuilding within the capital. To compensate for the large amount of housing lost during the war, high-rise blocks of flats came to dominate the skyline of London during the 1950s and 1960s. This helped to slow the outward expansion of the capital, but in 1965 the old county of London was replaced by the much larger area of Greater London, comprising the City of London and thirty-two new London boroughs. Today, London covers approximately 1,550 square kilometres (600 square miles). After several decades of decline its population is once again over 8 million, and vast amounts of construction – particularly of tall architectural works in the city centre – bear testimony to its thriving economy. In 2012, London once again hosted the Olympic Games, making it the only city to have done so three times (although Paris is scheduled to match this feat in 2024).

Westminster

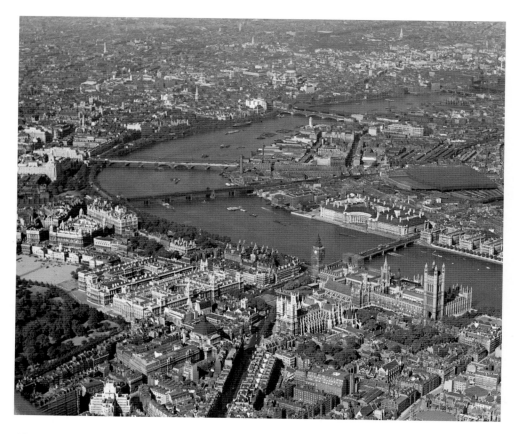

Above: Westminster Abbey, the Palace of Westminster and Government Buildings
The name Westminster originates from the informal description of the abbey as the West Minster in relation to the earlier East Minster, the Holy Trinity Priory at Aldgate in the City of London further down the River Thames. Today it is synonymous with the central government institutions of the United Kingdom. (© Historic England Archive. Aerofilms Collection)

Opposite above and below: Palace of Westminster, Parliament Square
Home to the House of Commons and the House of Lords, the Palace of Westminster is more commonly known as the Houses of Parliament. Originally a royal palace dating back to the eleventh century, Westminster remained the primary residence of the kings of England until it was badly damaged by fire in 1512. Thereafter, it became the seat of Parliament in England, which had met there since the thirteenth century. However, the palace is still owned by the monarch and retains its status as a royal residence. In 1834, the palace was almost entirely destroyed by an even greater fire. Reconstruction began in 1840 and over the ensuing thirty years it was rebuilt in the Gothic Revival style to designs by Charles Barry, assisted by Augustus Pugin, a leading authority on Gothic architecture and style, who designed the interior of the palace. (Historic England Archive; © Historic England Archive. Aerofilms Collection)

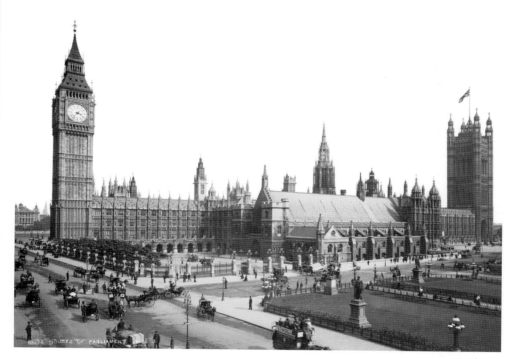

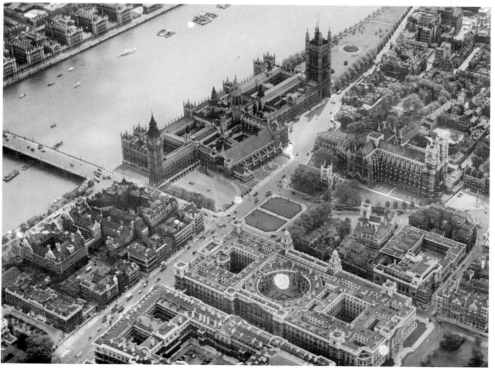

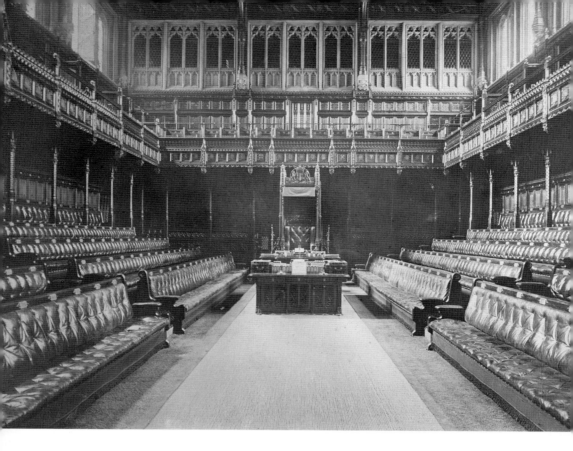

Above: House of Commons, Palace of Westminster
The House of Commons only acquired a permanent home at the Palace of Westminster in 1547, when St Stephen's Chapel became available. The chapel was periodically altered over successive centuries, culminating in a major renovation by Christopher Wren in the late seventeenth century. The current House of Commons was completely rebuilt after the fire of 1834, but the rectangular shape of it, with benches along opposite sides, copies the configuration of the chapel's choir stalls. This lends an adversarial atmosphere to debates that characterises the British parliamentary style. (Historic England Archive)

Opposite above: Westminster Hall, Palace of Westminster
Completed in 1099, Westminster Hall is the oldest building within Parliament and one of very few significant medieval structures to survive the 1834 fire. Measuring 73 metres by 20 metres (240 feet by 67 feet), the hall was at the time by far the largest in England – and probably in Europe. The magnificent hammer-beam roof, formed from great oak beams and strengthened by massive buttresses, provides a vast open space unobstructed by a single column, and 600 years later is still the largest medieval timber roof in northern Europe. (Historic England Archive)

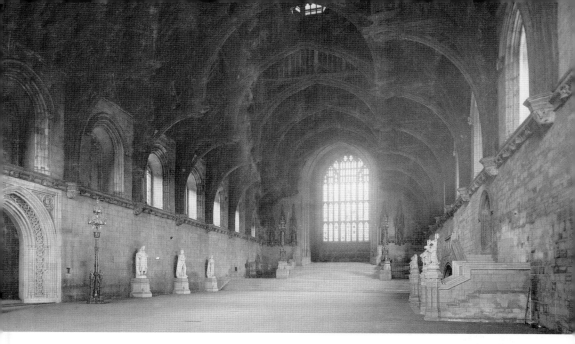

Elizabeth Tower and Big Ben
The clock tower was designed
by Sir Charles Barry with the
with the help of Augustus
Pugin and went into operation
in 1859. In 2012, it was
renamed the Elizabeth Tower
to commemorate the Diamond
Jubilee of Elizabeth II. Big Ben
is more accurately the nickname
for the Great Bell, at 13.7 tonnes
the largest of five bells housed
in the Tower, which tolls on
the hour. However, in August
2017, a four-year renovation
programme began, during which
the bells will be largely silent.
(Author's collection)

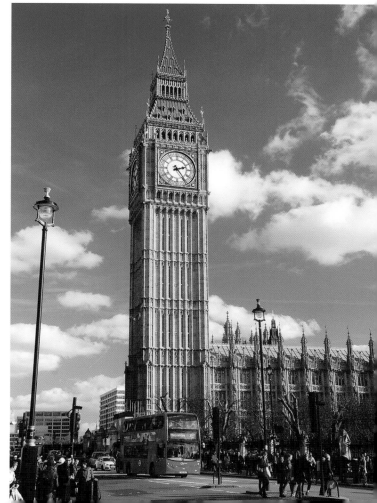

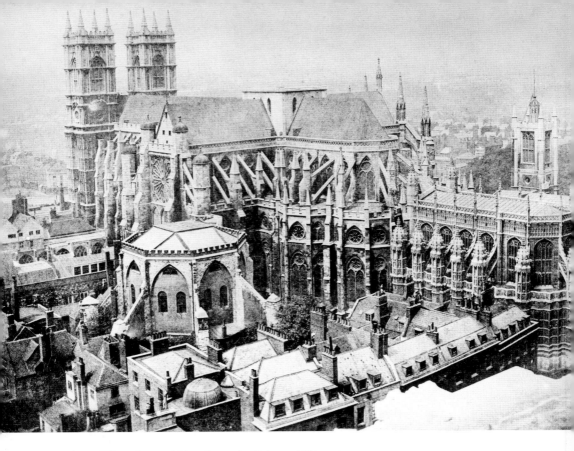

Above: Westminster Abbey from the Palace of Westminster
The recorded origins of the Collegiate Church of St Peter at Westminster – better known as Westminster Abbey – date back to an early Benedictine monastery founded in the 960s or early 970s. In the mid-eleventh century Edward the Confessor rebuilt it as a royal burial church, just in time for his own death in 1066. It was William the Conqueror therefore who was the first King of England to be crowned in the abbey later that year, and since then the coronations of all English and British monarchs have taken place there. Building work on the present church began in 1245. Technically speaking, the building has not been an abbey since 1560, but a 'Royal Peculiar' – a church responsible directly to the sovereign. (Historic England Archive)

Opposite above: Westerrn Façade, Westminster Abbey
The lower half of the western façade dates from the late fourteenth century, but the elaborate towers were added by Nicholas Hawksmoor and completed in 1745 to designs by Sir Christopher Wren. The column in the lower right corner is the Crimean War and Indian Mutiny Memorial. (Historic England Archive)

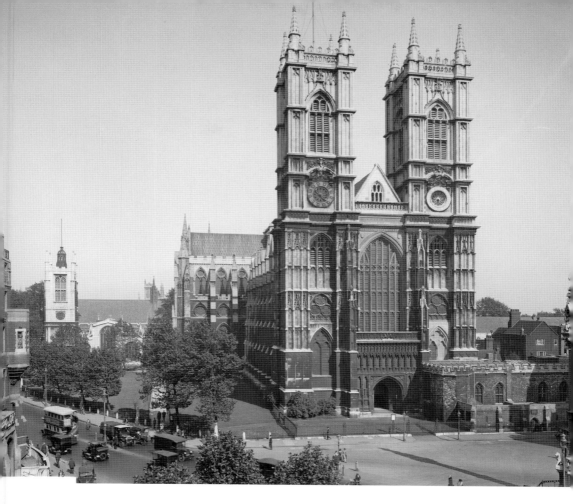

Right: Henry VII Chapel, Westminster Abbey
Building work on the chapel was begun
by Henry VII in 1503 and finished by his
son, Henry VIII. Designed in a very late
Perpendicular Gothic style, the English
poet John Leland described it as the 'orbis
miraculum' ('the wonder of the world'). The
chapel holds the tombs of seven monarchs
including Edward VI, Mary I, Elizabeth I,
James I, Charles II and Mary, Queen of Scots,
as well as that of Henry VII and his wife,
Elizabeth of York. (Historic England Archive)

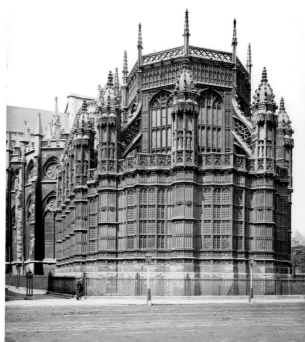

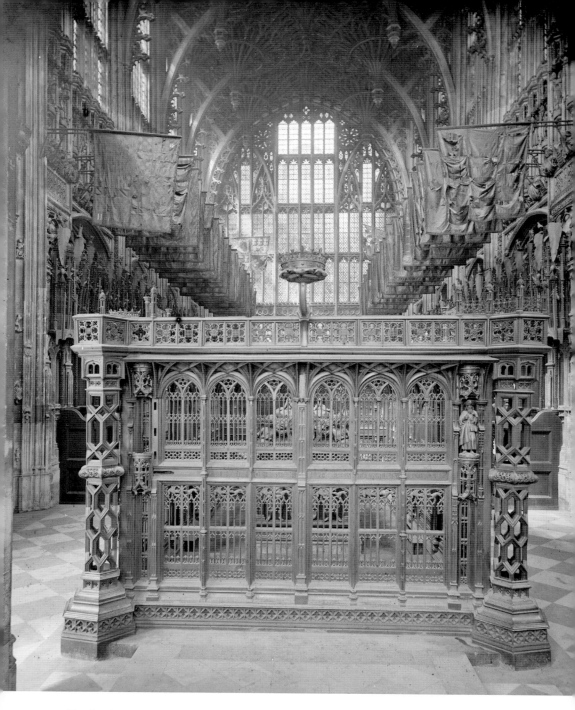

Tomb of Henry VII and Elizabeth of York, Lady Chapel
The tomb was designed by the Italian sculptor Pietro Torrigiano and constructed between 1512 and 1518. (Historic England Archive)

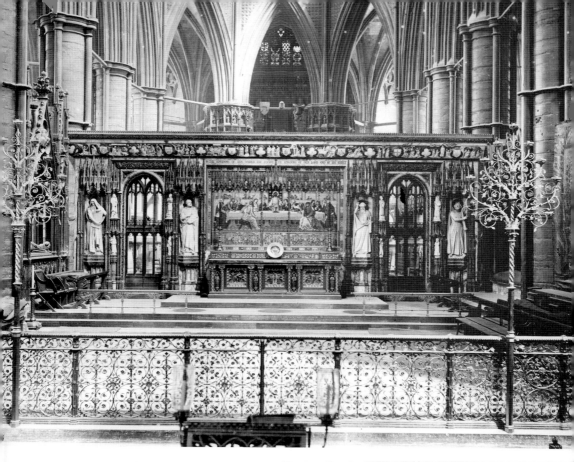

Above: Altar and Reredos, Westminster Abbey
Prince William and Kate Middleton were
married in front of the abbey's altar and
reredos (the screen behind) in April 2011. They
were designed Sir George Gilbert Scott and
erected in 1867. The mosaic of the Last Supper
is by Salviati, and the sculptures are by Henry
Hugh Armstead. (Historic England Archive)

Right: Poets' Corner, Westminster Abbey
Poets' Corner is the name traditionally
given to a section of the south transept of
Westminster Abbey where a large number of
poets, playwrights and writers are buried and
commemorated. The first writer to be buried
there was Sir Geoffrey Chaucer, but this was
more in his capacity as Clerk of Works to
Westminster rather than for his verse. The
photograph shows the tomb of Alfred Lord
Tennyson, bedecked with floral tributes.
(Historic England Archive)

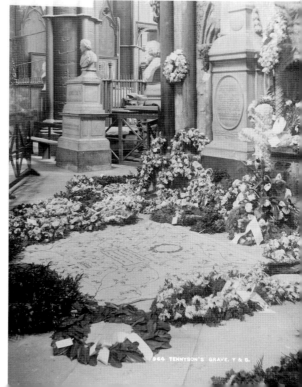

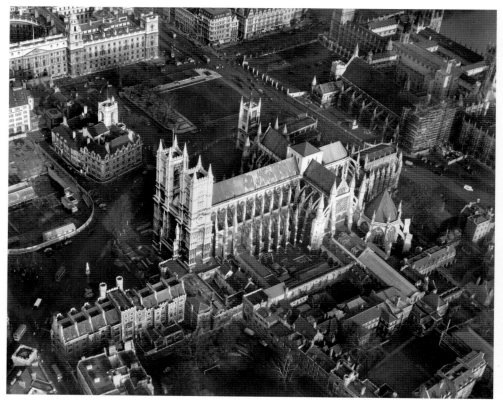

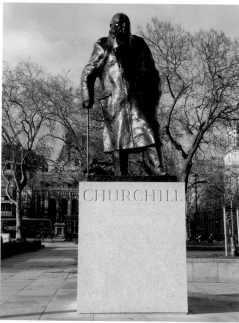

Above: Westminster Abbey
An aerial view of Westminster Abbey, with Parliament Square behind. (© Historic England Archive. Aerofilms Collection)

Left: Statue of Winston Churchill, Parliament Square
The statue of Winston Churchill was sculpted by Ivor Roberts-Jones, and is 3.7 metres (12 feet) tall and made of bronze. It was unveiled on 1 November 1973 by Churchill's widow, Clementine, Baroness Spencer-Churchill, in a ceremony attended by Elizabeth II, the then Prime Minister Edward Heath and four former prime ministers. (Author's collection)

Whitehall

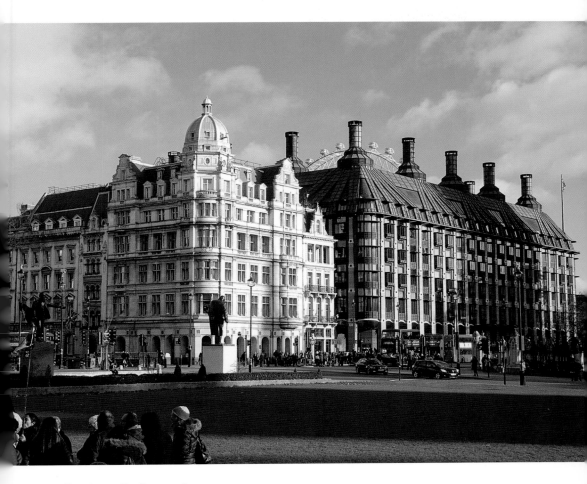

Portcullis House, Parliament Square
Portcullis House (in the right of the image), named after the chained portcullis that symbolises Parliament, was commissioned in 1992 and designed by architects Michael Hopkins & Partners at a final cost of £235 million. Built at the same time as the new interchange station for the Jubilee Line Extension in Westminster tube station below, it opened in 2001 to provide office space for around one third of the Members of Parliament. The external design reflects both the Norman Shaw Buildings next door and the Victorian Gothic design of the Palace of Westminster opposite. The interior resembles a ship, recalling Britain's proud maritime traditions. (Author's collection)

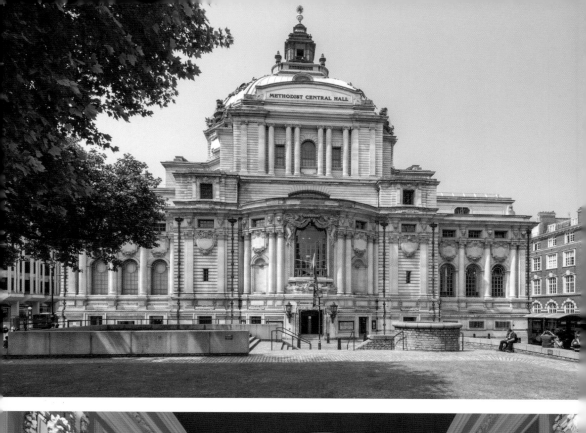

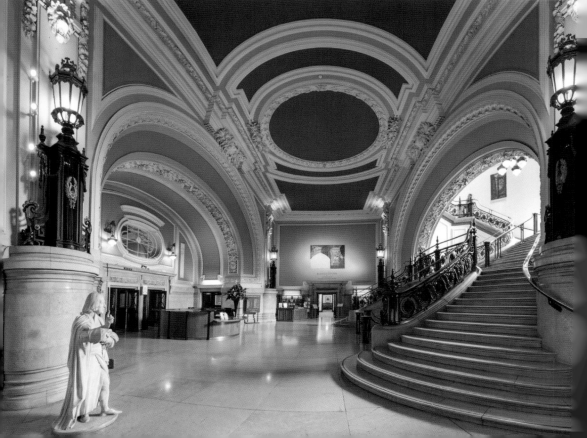

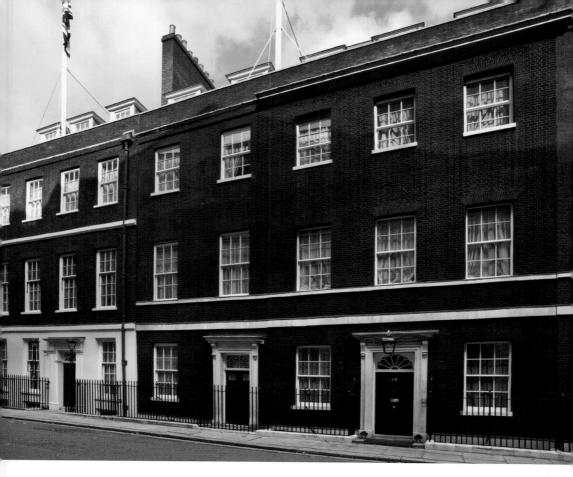

Above: No. 10 Downing Street, Westminster
No. 10 Downing Street has been the official residence of every prime minister for almost three centuries. It was originally part of the Palace of Whitehall, created by Henry VIII, until it was destroyed by fire in 1698. The first domestic house built on the site was leased in 1581 to Sir Thomas Knyvet, a favourite of Elizabeth I who, in 1605, led the arrest of Guy Fawkes for his role in the Gunpowder Plot. In 1682, George Downing, a diplomat and government administrator, secured the leases to the property and employed Sir Christopher Wren to design a terrace along the north side of the new Downing Street. George II presented No. 10 Downing Street as a gift to Sir Robert Walpole, First Lord of the Treasury and effectively the first prime minister, who took up residence on 22 September 1735. (© Historic England Archive)

Opposite above and below: Methodist Central Hall, Storey's Gate 942
Methodist Central Hall was built in 1905–11 to mark the centenary of John Wesley's death. It was designed by Edwin Alfred Rickards. Although clad in an elaborate baroque style, the self-supporting ferro-concrete structure of the Great Hall's domed ceiling is reputedly the second largest of its type in the world. Still primarily used as a Methodist church, Methodist Central Hall is an important conference centre, art gallery and office building. It has staged many significant political events including early meetings of the suffragette movement and the first meeting of the United Nations General Assembly in 1946. (© Historic England Archive)

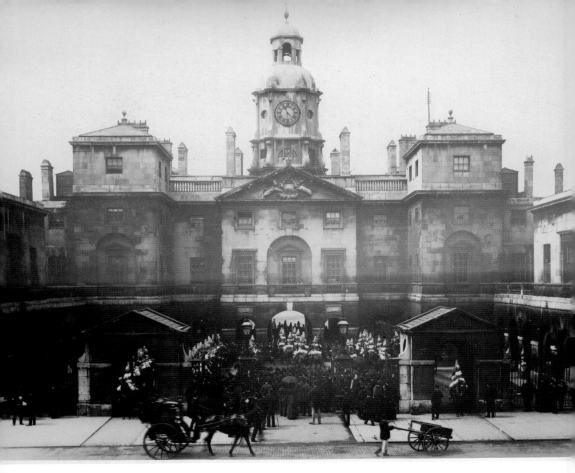

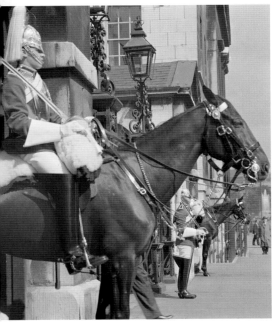

Above and left: The Relieving of the Guard, Horse Guards, Whitehall, and the Queen's Life Guard on Guard Duty

The first Horse Guards building was commissioned by Charles II in 1663 and originally formed the entrance to the Palace of Whitehall, which is the reason it is still ceremonially defended by the Queen's Life Guard. In 1745, George II commissioned a new building in the fashionable Palladian style by the architect William Kent, and in 1803–05 a further two floors were added to these, giving the building its present appearance.

At the time, the building served both as the headquarters of the Commander-in-Chief of the British Army – frequently a prominent member of the royal family – and administrative offices for the Secretary at War. Perhaps reflecting Horse Guards' two masters, the clock sited in the turret above the main archway has two faces, one facing Whitehall and the other towards Buckingham Palace. Prior to the completion of Big Ben in 1859, the Horse Guards Clock was the main public clock in Westminster. (Historic England Archive; © Historic England Archive)

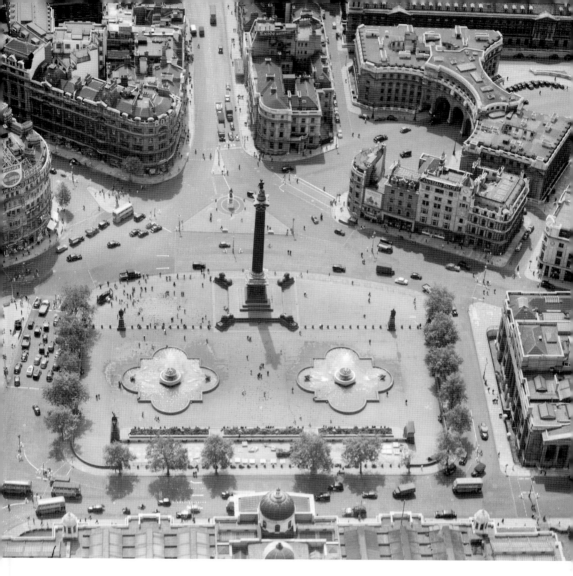

Trafalgar Square

From Edward I's reign in the thirteenth century, the area was the site of the King's Mews, where hawks for hunting and sport were kept. After a fire in 1534, it became the courtyard of the Great Mews stables for Henry VIII's new Palace of Whitehall. At the beginning of the eighteenth century George IV moved the stables to Buckingham Palace, and its architect, John Nash, began to develop the vacant plot as a cultural space open to the public. Nash died before the work could be completed, however, and Sir Charles Barry developed it into the square we see today. It was originally intended to be named in honour of William IV, but another architect, George Ledwell Taylor, suggested it be used to commemorate Nelson's 1805 victory at the Battle of Trafalgar. Trafalgar Square was opened to the public on 1 May 1844. (© Historic England Archive. Aerofilms Collection)

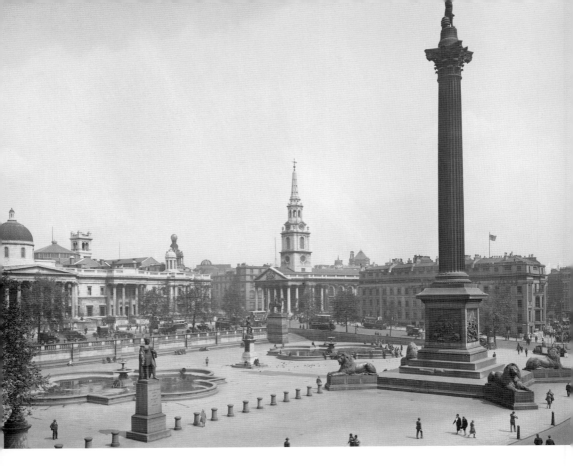

Nelson's Column, Trafalgar Square

Nelson's Column was planned separately to the work of Barry, who opposed it. William Railton designed the column and statue to honour Admiral Nelson after his victory in the Battle of Trafalgar off the coast of Spain in 1805. Railton's original design for a 66.5-metre (218-foot) Corinthian column was reduced by one third after public objections. The 5-metre (16-foot) granite statue at the top was sculpted by E. H. Baily and raised into position in November 1843. It stands on a bronze platform forged from old guns from the Woolwich Arsenal Foundry, while four bronze panels at the base of the column depict some of Nelson's battles. (Historic England Archive)

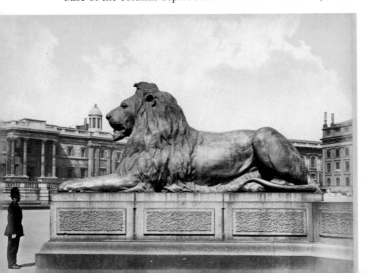

Bronze Lions, Nelson's Column
Sir Edwin Landseer designed the bronze lions said to guard Nelson's Column in 1867. Each weighs 7 tons. Landseer worked from a lion that had died at London Zoo, but he took so long to complete the sketches for the sculpture that the corpse began to decompose and some parts had to be improvised. As a result, the paws on the statues resemble those of cats more than lions. (Historic England Archive)

National Gallery, Trafalgar Square
The National Gallery was built on the north side between 1832 and 1838 to a design by William Wilkins. For both Wilkins and Barry, a major consideration was increasing the visual impact of the National Gallery, which had been widely criticised for its lack of grandeur. Barry solved the problem of the complex sloping site by excavating the main area of the square to the level of the footway between Cockspur Street and the Strand. He then constructed a 4.6-metre (15-foot) balustraded terrace with a roadway on the north side, and steps at each end down to the main level. In a major works project completed in July 2003 the north terrace was pedestrianised to join the National Gallery to the square below.
(© Historic England Archive)

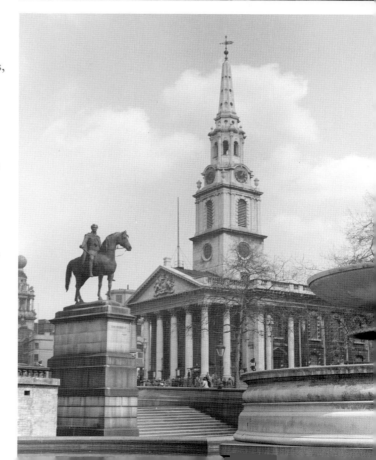

Church of St Martin-in-the-Fields, Trafalgar Square
This church is dedicated to Saint Martin of Tours and has stood on the site since at least 1222. Henry VIII had it rebuilt in 1542 to prevent plague victims from having to pass through his Palace of Whitehall. At that time, it lay literally 'in the fields' between the cities of Westminster and London. The present building was constructed in a neoclassical style by James Gibbs in 1722–26. Dick Sheppard, vicar from 1914 to 1927, described it as the 'Church of the Ever Open Door', and it continues to work with young and homeless people. The statue by Chantrey in the foreground dates from 1834 and is of George IV.
(Historic England Archive)

The Mall

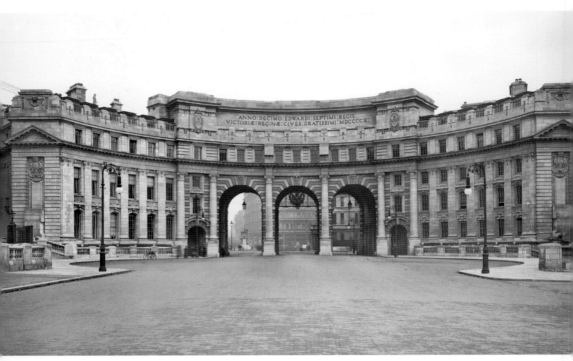

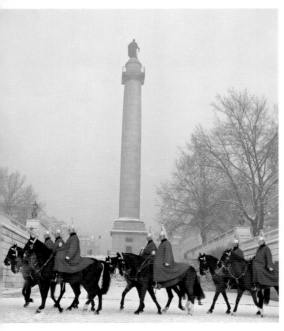

Above and left: Admiralty Arch, The Mall
Admiralty Arch stands astride The Mall and was designed by Aston Webb, who also designed the Victoria Memorial and the new façade of Buckingham Palace at the other end of the promenade. The arch was commissioned by Edward VII in memory of his mother, Queen Victoria, although he died before its completion in 1912. To the south, it connects with the Old Admiralty Building – hence its name – and was previously the residence of the First Sea Lord. In 2012 the government sold a 125-year lease over the building to redevelop it into a luxury hotel, restaurant and apartments. The figures at either end of the two wings are of Navigation and Gunnery, and were designed by Thomas Brock.

The image on the left shows the Household Cavalry passing the Duke of York Column along The Mall between Admiralty Arch and Buckingham Palace. (Historic England Archive; © Historic England Archive)

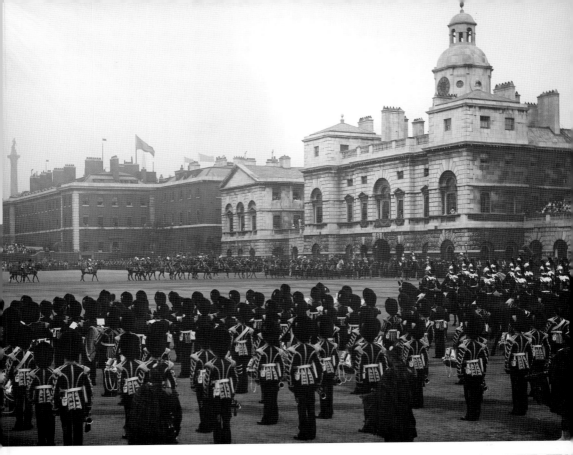

Above and right: Trooping the Colour, Horse Guards Parade

Trooping the Colour is a ceremony that dates back to the seventeenth century when the Colours of a regiment were used to rally its troops in battle and were therefore 'trooped' in front of the soldiers every day to make sure that they would recognise them. The ceremony is performed on Horse Guards Parade by the seven regiments that form the Household Division, which contains two cavalry and five footguard. Since 1748, the ceremony has also marked the official birthday of the British sovereign, held on a Saturday in June.

Each year, one of the footguard regiments is selected to troop its colour through the ranks of the others. The Household Division as a whole then marches past the Queen. The massed bands of the footguard and the mounted band of the Household Cavalry, together with a corps of drums, play military music throughout. In all, over 1,000 officers and men parade, as well as 200 horses. (Historic England Archive; © Historic England Archive)

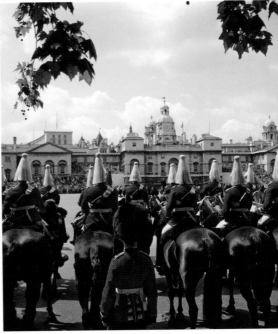

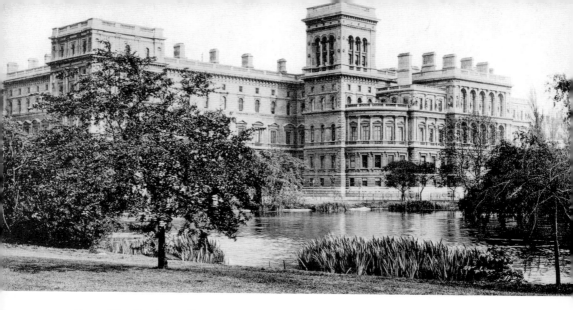

Above: The Foreign Office, Viewed from St James's Park

The Foreign Office was built in 1861–68 to Italianate designs by Sir George Gilbert Scott and Sir Matthew Digby Wyatt. Scott initially envisaged a Gothic design, but Lord Palmerston, the then prime minister, insisted on a classical style. The allegorical figures ('Art', 'Law', 'Commerce', etc.) around the exterior are by Henry Hugh Armstead and John Birnie Philip. The building originally housed four separate government departments: the Foreign Office, the India Office, the Colonial Office and the Home Office. The former were progressively merged into the Foreign & Commonwealth Office, but by the 1960s the building had become so overcrowded it was tabled for demolition as part of a major redevelopment. This was blocked by public protest, however. Instead the building was listed in 1970, the Home Office moved out in 1978 and a £100 million restoration programme began two years later. (Historic England Archive)

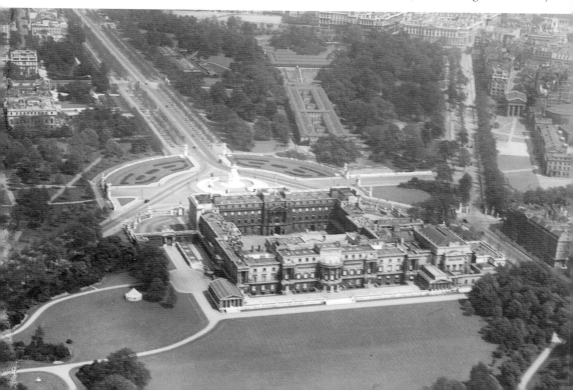

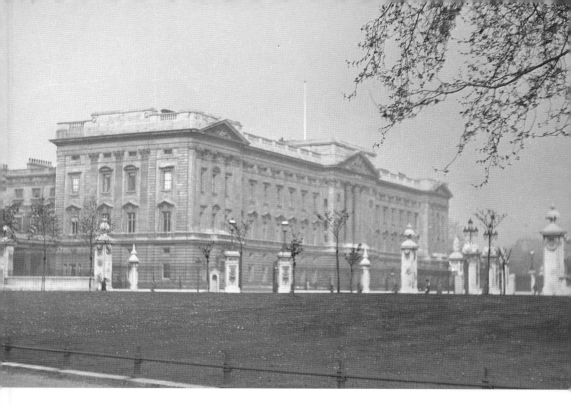

Above and opposite below: Buckingham Palace, Westminster

Buckingham Palace has served as the official London residence of UK sovereigns since 1837. The building at the core of today's palace was a large town house built for the Duke of Buckingham in 1703. George III bought Buckingham House in 1761 as a private residence for his wife and it became known as the Queen's House. In 1826 George IV decided to transform it into a palace. His architect, John Nash, retained the main block but doubled its size by adding a new suite of rooms on west side, which were faced in Bath stone. However, by 1829 the project had become so expensive that it cost Nash his job, and on the death of George IV in 1830, William IV engaged Edward Blore to finish the work. However, the new king never took up residence, and when the Palace of Westminster was destroyed by fire in 1834, he offered it as a new home for Parliament.

The offer was declined, and instead Queen Victoria was the first reigning monarch to occupy the palace. She had Blore add the fourth wing, thereby creating an internal quadrangle behind a new east façade. By the beginning of the twentieth century the soft French stone used in Blore's east front was showing signs of deterioration, and in 1913 Sir Aston Webb designed a new façade in Portland stone. This includes the well-known balcony on which the royal family periodically appears in public. In all, Buckingham Palace has 775 rooms, including ninety state rooms, fifty-two royal and guest bedrooms, 188 staff bedrooms, ninety-two offices and seventy-eight bathrooms. (© Historic England Archive. Aerofilms Collection; Historic England Archive)

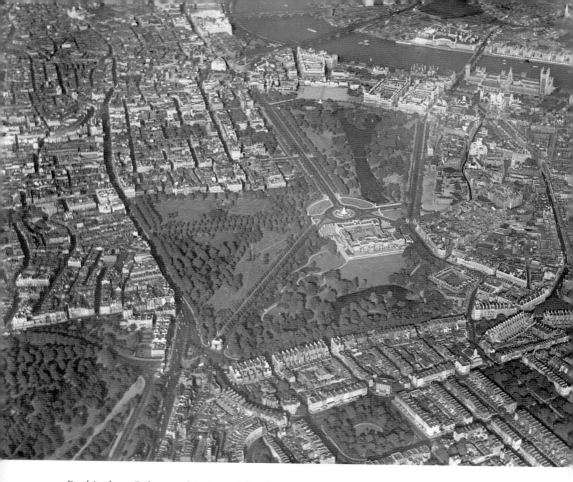

Buckingham Palace and St James's Park
An aerial view looking east over Buckingham Palace and St James's Park towards the River Thames. (© Historic England Archive. Aerofilms Collection)

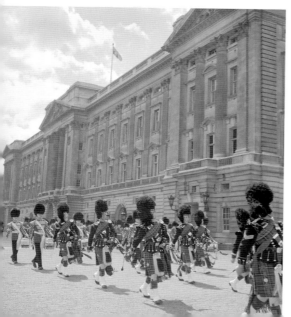

Changing of the Guard Ceremony, Buckingham Palace
The Changing of the Guard ceremony takes place in the forecourt of Buckingham Palace, which together with the gates and railings was formed in 1911 as part of the scheme that erected the Victoria Memorial in front. When Queen Victoria moved into Buckingham Palace in 1837, the Queen's Guard remained at St James's Palace, with a detachment guarding Buckingham Palace. The Changing of the Guard ceremony marks the moment when the soldiers currently on duty, the Old Guard, form up in front of the palace and are relieved by the New Guard, arriving from Wellington Barracks on the south side of St James's Park. (© Historic England Archive)

Kensington and Hyde Park

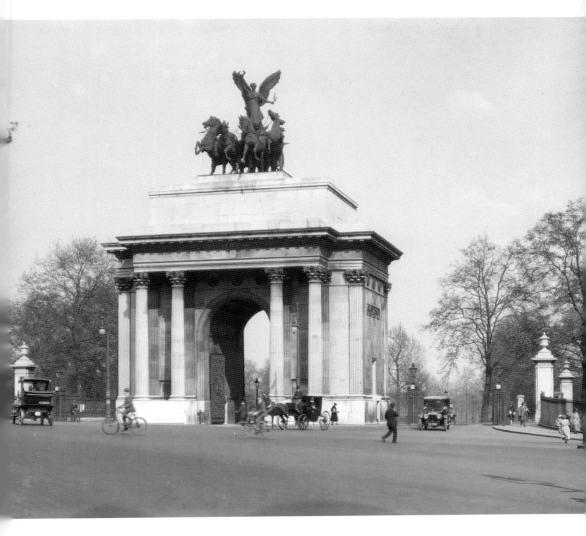

Wellington Arch, Hyde Park Corner

By the eighteenth century Hyde Park Corner became regarded as the western gateway into London. In 1826 Decimus Burton produced a design for a triumphal arch topped with a gilded quadriga (a chariot drawn by four horses) as an outer entrance into Buckingham Palace. The Treasury declined to pay for the sculpture, however, and instead a committee came up with a plan to erect a giant equestrian statue on top of the arch as a memorial to the Duke of Wellington. When Matthew Cotes Wyatt's equestrian statue, the largest ever created, was erected on the arch in 1846, it was widely derided, but Wellington threatened to resign all his public posts if it were removed. After Wellington's death, the statue was moved to Aldershot Garrison, the home of the British Army, and in 1912 Adrian Jones' quadriga depicting the Angel of Peace, the largest bronze sculpture in Europe, was erected in its place. (Historic England Archive)

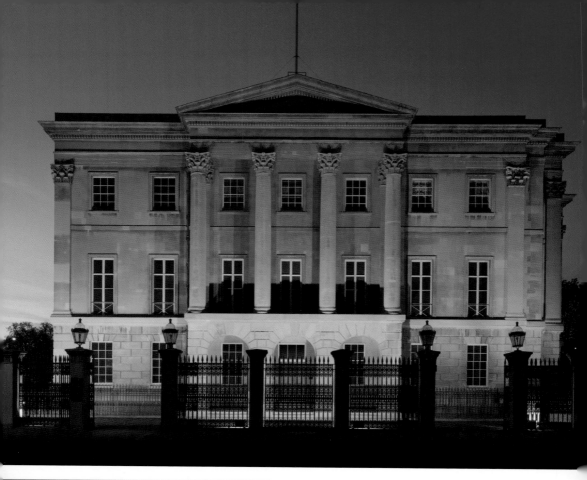

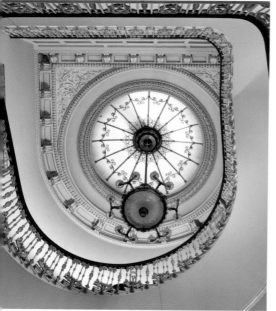

Above, left and opposite: Apsley House, Hyde Park Corner

In keeping with the popular idea of Hyde Park Corner as the western gateway into London, this elegant Georgian building was once known as 'Number 1 London'. The house was originally built in red brick by Robert Adam between 1771 and 1778 for Lord Apsley, the then Lord Chancellor. It was purchased in 1807 by Richard Wellesley, 1st Marquess Wellesley, the elder brother of Sir Arthur Wellesley, but in 1817 financial difficulties forced him to sell it to the latter, by then the Duke of Wellington, who needed a London base for his new political career. Wellington employed Benjamin Dean Wyatt to renovate the house in two phases: in the first, begun in 1819, a three-storey extension was added, housing a State Dining Room, bedrooms and dressing rooms; the second phase, started after Wellington had become prime minister in 1828, included a new staircase and the 'Waterloo Gallery'. It was during this phase that the red-brick exterior was clad in Bath stone, and a pedimented portico added. (Historic England Archive)

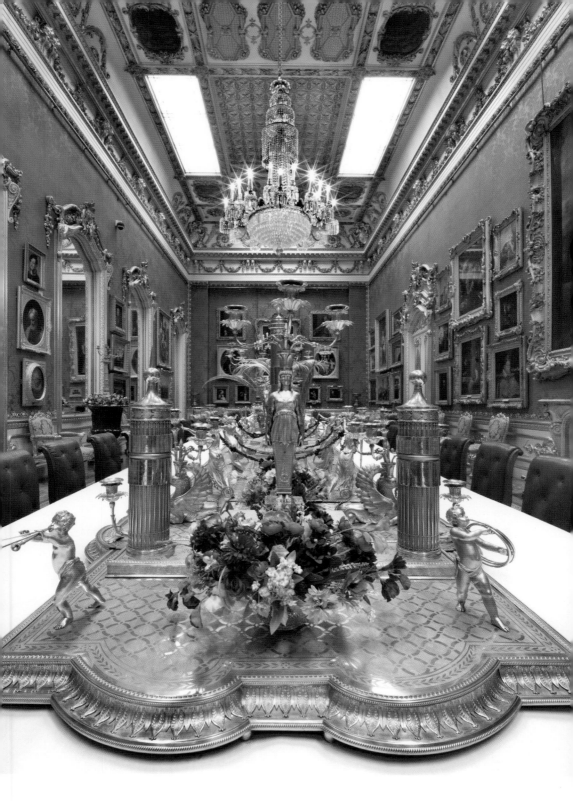

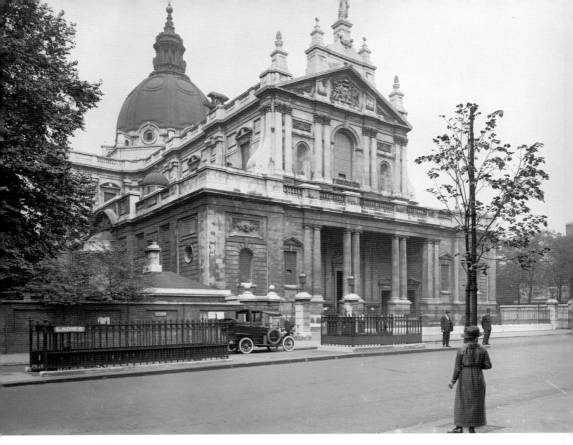

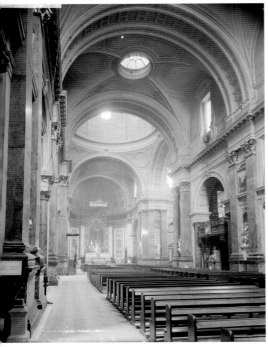

Above and left: Brompton Oratory, Brompton Road The Church of the Immaculate Heart of Mary is a large neoclassical Roman Catholic church, more commonly known as the Brompton Oratory. The Institute of the Oratory was founded in Rome in the sixteenth century and introduced to England by Cardinal Newman in the mid-nineteenth century. (Newman was beatified during the Pope's visit to London in 2010.) The church was built by Herbert Gribble between 1880 and 1884 and is closely connected with the London Oratory School, a boys' school founded by the priests.

The church is faced in Portland stone, with the vaults and dome in concrete. The latter was heightened in profile and the cupola added in 1895, giving it a height of 200 feet (61 metres), and making it the largest Catholic church in London before the opening of Westminster Cathedral in 1903. Devon marble was used in the pilasters and the columns, with more exotic marbles in the apse and the altars, and carvings in metalwork, plasterwork, wood and stone. The church also houses an important library. (Historic England Archive)

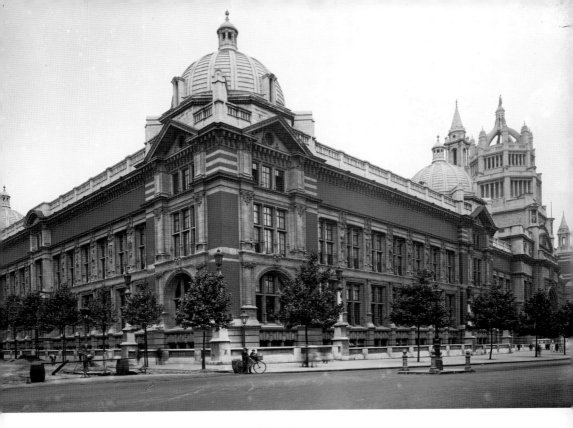

Above: Victoria and Albert Museum, Cromwell Road

The 'V&A' is the world's largest museum of decorative arts and design, housing a permanent collection of over 2.3 million objects. It was founded in 1852 and officially opened by Queen Victoria in 1857. Its origins lie in the Great Exhibition of 1851, and several of the exhibits displayed there were later purchased to form the nucleus of the collection. Today, the collection spans 5,000 years of art, and is among the best and the largest in the Western world. The museum is housed in the original Brompton Park House, which has been variously extended over the decades. The laying of the foundation stone of the Aston Webb building (to the left of the main entrance) on 17 May 1899 was the last official public appearance by Queen Victoria, and it was her son and successor King Edward VII who presided over the opening ceremony ten years later. (Historic England Archive)

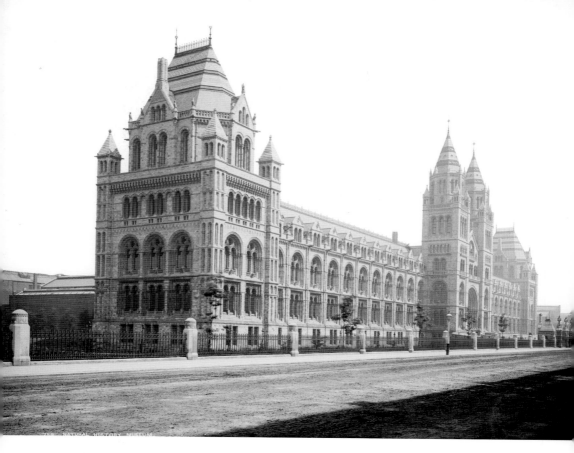

Above and opposite above: Natural History Museum

The Natural History Collection was initially housed at the British Museum in Bloomsbury, but by the early nineteenth century, the inability of the curators there to conserve the specimens in their charge became notorious. They were eventually rescued by the palaeontologist Richard Owen, appointed Superintendent of the natural history departments of the British Museum in 1856. On his initiative land was purchased in South Kensington and a competition held to design a new museum. The winning entry was by Captain Francis Fowke, but he died shortly afterwards and the scheme was taken over by Alfred Waterhouse, who substantially revised the agreed plans and designed the façades in his own idiosyncratic Romanesque style. Building took place between 1873 and 1880, and the new museum opened the following year. After various additions and extensions, the museum today contains 3 acres of gallery space and has been dubbed a 'cathedral of nature'. (Historic England Archive)

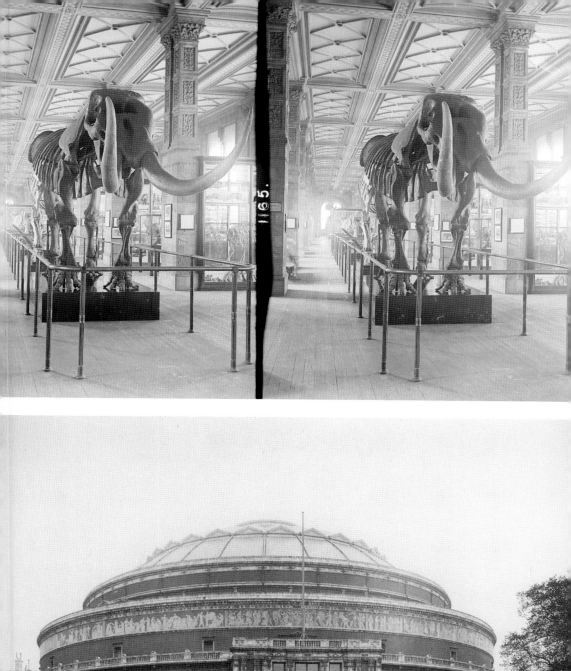
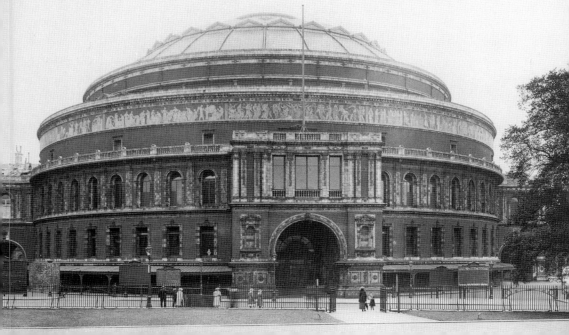

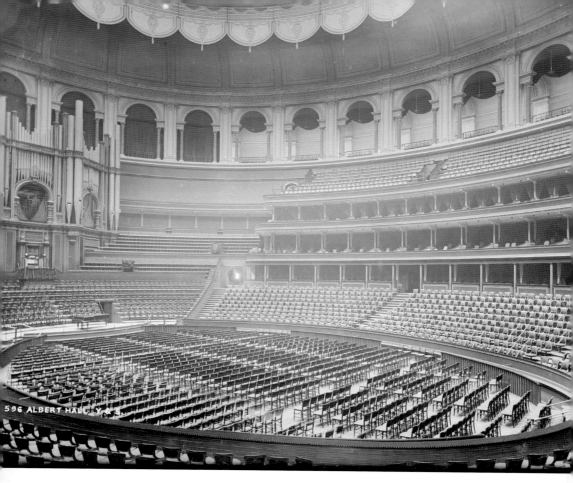

Above and previous below: Royal Albert Hall

With some of the proceeds from the 1851 Great Exhibition, Prince Albert proposed Gore House and its grounds as the site for a hall to promote 'the advancement of the arts and sciences and works of industry of all nations'. At the foundation ceremony in 1867 Queen Victoria named the hall after the Prince Consort, who had died almost six years earlier without seeing his vision fulfilled. In their design of the Royal Albert Hall, Captain Francis Fowke and Major-General Henry Y. D. Scott of the Royal Engineers were heavily influenced by ancient amphitheatres. It was constructed mainly of Fareham red brick, with terracotta block decoration. The dome designed by Rowland Mason Ordish is made from a 338-tonne iron metal frame, supporting 279 tonnes of glazing. Around the outside of the building is a great mosaic frieze containing sixteen subjects, depicting 'The Triumph of Arts and Sciences'. (Historic England Archive)

Opposite: Albert Memorial

Albertopolis is the nickname given to the area lying between Hyde Park and Cromwell Road to the south. It is named after Prince Albert and contains many educational and cultural amenities built with the proceeds from the Great Exhibition he planned with Henry Cole and held in Hyde Park in 1851. In 1862, the year after Albert's death, Queen Victoria decided to erect a memorial to her beloved husband, and the Lord Mayor, William Cubitt, a building contractor, undertook to raise funds for it through public subscription. In 1863, the Queen selected a design for the Memorial by Sir George Gilbert Scott, who was knighted as a result. The seated figure of Albert is by John Henry Foley, who died one year before the bronze statue was added to the Memorial in 1875. (Historic England Archive)

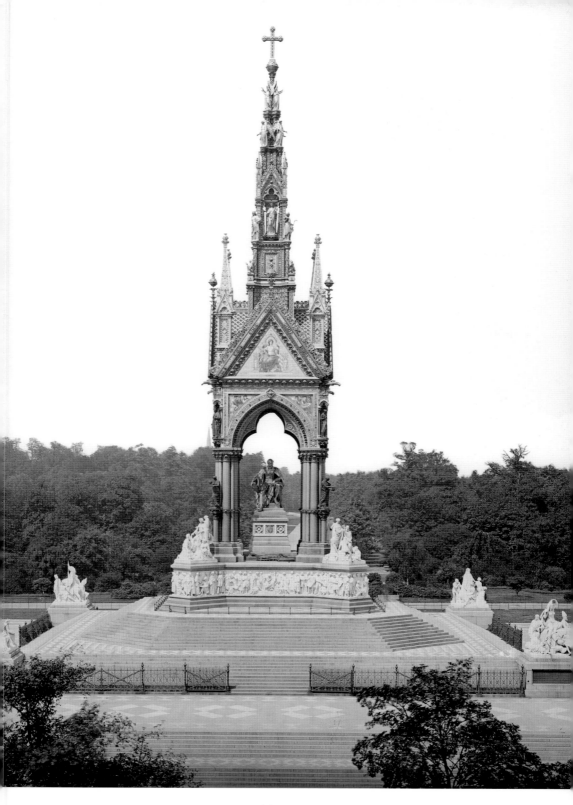

Oxford Street to Covent Garden

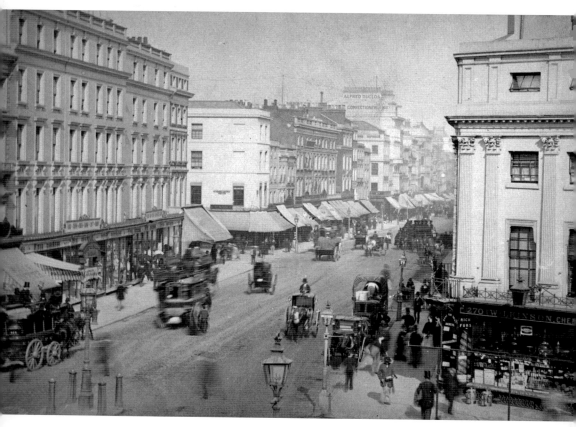

Above: Oxford Street
A view looking along Oxford Street. (Historic England Archive)

Opposite above: Selfridges in the Year of Its Opening
Selfridges flagship store on Oxford Street is the second largest shop in the UK (after Harrods) and opened in 1909. The original London store was designed by Daniel Burnham, the leading American department store designer of the time, in the American commercial Beaux Arts style. It is one of the earliest examples of steel cage frame construction for this type of building in London, and pioneered the eventual widespread use of this building method in the UK. Other architects involved in the design of the store include Burnham's fellow American Francis Swales, who worked on decorative details, and R. Frank Atkinson and Thomas Smith Tait. The distinctive polychrome sculpture above the Oxford Street entrance is the work of British sculptor Gilbert Bayes. (Historic England Archive)

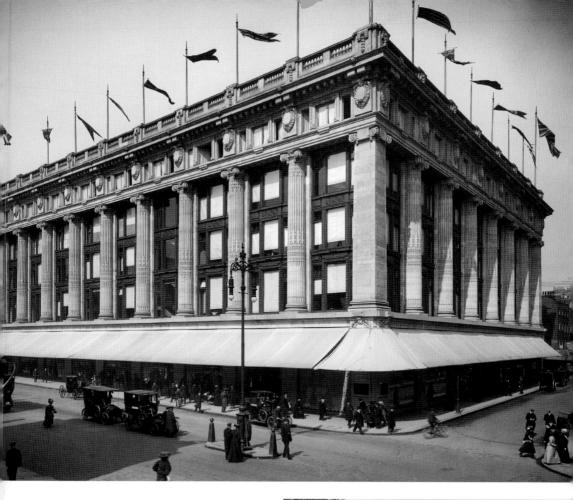

Right: Selfridges, Decorated for the Coronation of King George VI

The retail chain was founded by American Harry Gordon Selfridge. He aimed to make shopping a form of leisure instead of a chore, and is popularly credited with coining the phrase 'the customer is always right'. He transformed the department store into a social and cultural landmark that provided a customer-friendly environment and a welcoming atmosphere – techniques that have been adopted around the world. The shop's early history was dramatised in ITV's 2013 series *Mr Selfridge*. The *Daily Telegraph* named Selfridges in London the world's best department store in 2010. (Historic England Archive)

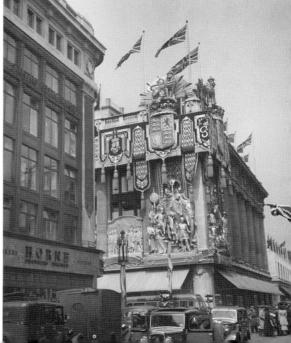

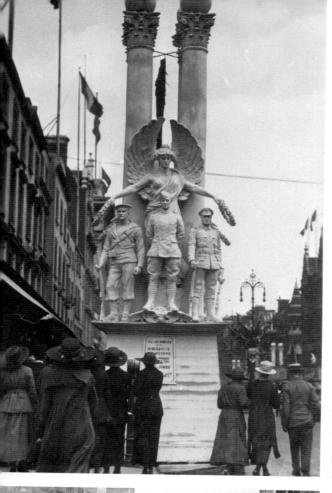

Court of Honour, Selfridges
A group of women looking up at the
'Court of Honour', erected outside
Selfridges department store for the
First World War peace celebrations.

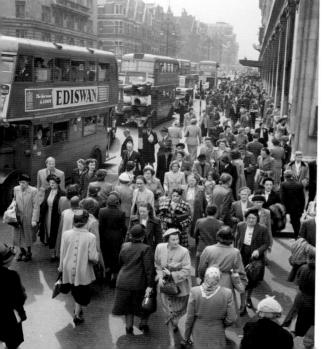

Shoppers, Oxford Street
Running from Marble Arch to Tottenham
Court Road, and originally a Roman
road, Oxford Street was known as Tyburn
Road during the Middle Ages, and lay
at the end of the route from Newgate
Prison to the gallows at Tyburn, near the
present site of Marble Arch. It became
known as Oxford Road and then Oxford
Street in the eighteenth century, and
had evolved from being residential to
retail in character by the late nineteenth
century. The first department stores in
Britain, such as Selfridges, John Lewis
and HMV, opened on Oxford Street in
the early twentieth century. Today, it is
Europe's busiest shopping street, with
approximately 300 shops and around
half a million daily visitors. (© Historic
England Archive)

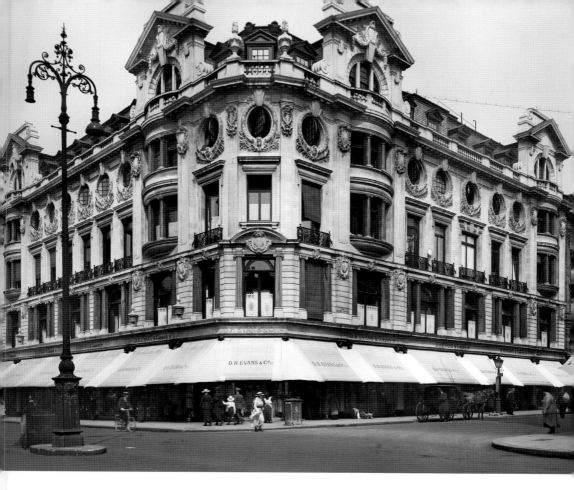

D. H. Evans, Nos 308–318 Oxford Street, June 1917. (Historic England Archive)

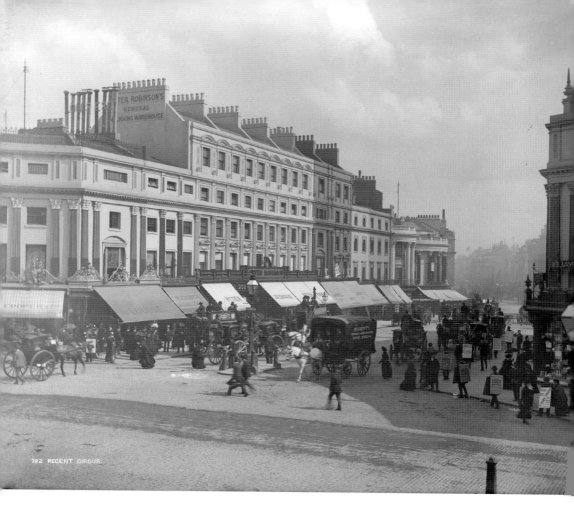

Above: Peter Robinson, Oxford Circus

Peter Robinson opened a drapery store on Oxford Street in 1833 and by 1850 he was able to establish a department store on the north-east corner of Oxford Circus, which was renowned for fashionable ladies' clothes and accessories. At the time John Lewis worked for Peter Robinson, initially as a drapery assistant. In 1864 he was offered a partnership in the business, but declined; instead he opened his own store on Oxford Street, before founding his own eponymous retail chain. Peter Robinson continued to flourish until the 1960s when, in an attempt to liven up its image and attract younger customers, the basement of the Oxford Circus store was converted into 'Peter Robinson Topshop'. By the end of the 1970s the Peter Robinson brand had all but disappeared, but the building on Oxford Circus continues as the flagship store for its offspring, Topshop. (Historic England Archive)

Opposite above: All Souls Church, Langham Place

This church was designed in Regency style by John Nash, favourite architect of George IV, and consecrated in 1824. Built of Bath stone, it consists of a prominent spired circular vestibule, designed to provide an eye-catching monument at the point where Regent Street turns abruptly westward to follow the line of Portland Place. As Broadcasting House stands just behind, the BBC often broadcasts from the church. (Historic England Archive)

Below: Liberty, Great Marlborough Street

Arthur Lasenby Liberty opened his eponymous shop in 1875 with a £2,000 loan from his future father-in-law, and originally employed three staff members. Over the following years neighbouring properties were added and the store grew to become the most fashionable place to shop in London. Built in 1924, the Arts and Crafts Tudor-style building in Great Marlborough Street was designed by Edwin and Stanley Hall as a reaction to the early twentieth-century vogue for stone-dressed steel-framed buildings. The façade was built using timbers from two Royal Navy ships, HMS *Impregnable* and HMS *Hindustan*, and is exactly the same length as the latter. (Historic England Archive)

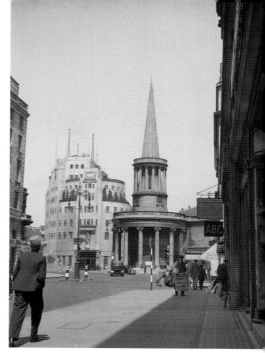

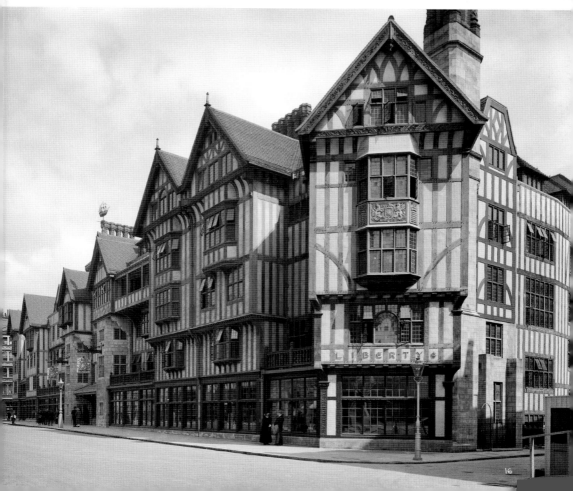

16

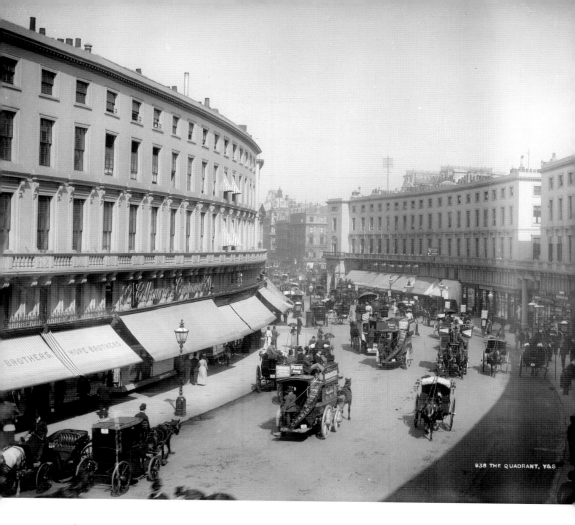

The Quadrant, Regent Street

Regent Street, named after the Prince Regent (later George IV), is a major shopping street running south from Oxford Circus. It was designed by John Nash and completed in 1825. Nash originally wanted to construct a straight boulevard, but this was not possible because of issues with landownership. The centrepiece, known as the Quadrant, was designed for 'shops appropriated to articles of fashion and taste', and built with a colonnade made out of cast-iron columns to allow pedestrians to walk sheltered from rain. By the end of the nineteenth century, however, the original buildings were considered too small and outdated for fashionable shopping. A century after Nash, the entire street was remodelled in the Beaux Arts style, with separate buildings on a grand scale assembled to harmonise and produce an impressive overall effect. Each block had to be designed to provide a continuous unifying street façade and finished in Portland stone. The stylistic tone for the rebuilding was set by Sir Reginald Blomfield's Quadrant, started in 1923 and completed by 1928. The only remaining Nash building in Regent Street today is All Souls Church. (Historic England Archive)

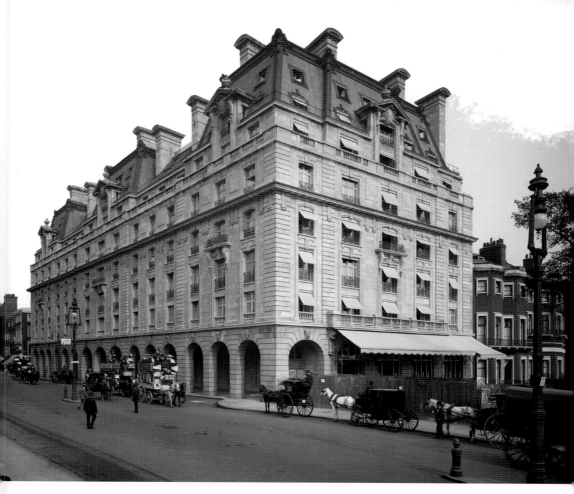

The Ritz Hotel, Piccadilly

A symbol of high society and luxury, the Ritz is one of the world's most prestigious and best-known hotels. It was conceived by the famous Swiss hotelier César Ritz and opened in 1906. It was designed in the neoclassical style of Louis XVI by Arthur Davis and Charles Mewès, the architect for the Hôtel Ritz in Paris, to resemble a stylish Parisian block of flats. At the corners of the pavilion roofs are large green copper lions, the hotel's emblem. The opulent interiors and lavish furnishings are also in the Louis XVI style, none more so than the cream-coloured Palm Court, with its panelled mirrors in gilt bronze frames, that hosts the famous 'Tea at the Ritz'. (Historic England Archive)

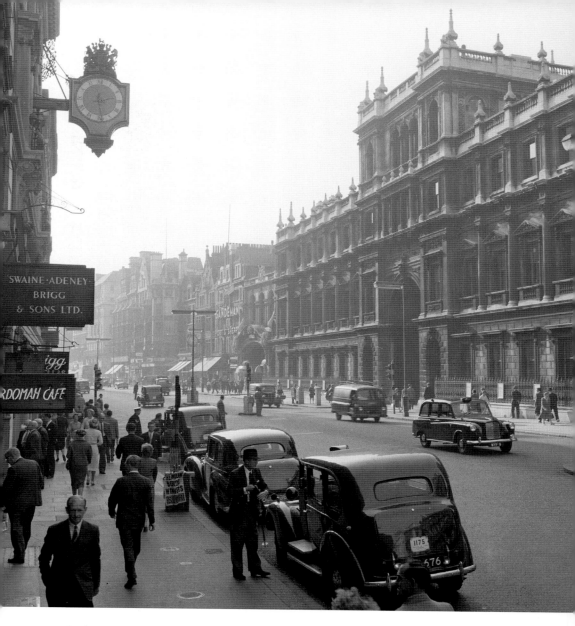

Burlington House, Piccadilly

Burlington House was one of the earliest large private residences built on the north side of Piccadilly from the 1660s onwards. Around 1717, the 3rd Earl of Burlington began making major modifications to the house, for which he appointed Colen Campbell as his architect. This was a key moment in the history of English architecture, as Campbell – like Burlington – was a devotee of the Palladian style. Together with William Kent, who worked on the interiors at Burlington House, they had a major influence over the direction of English architecture and interior decoration for two generations. In 1854, Burlington House was sold to the British government with the intention of demolishing the building and using the site for the University of London. After public protest halted this plan, the Royal Academy took over the main block in 1867 on a 999-year lease. (© Historic England Archive)

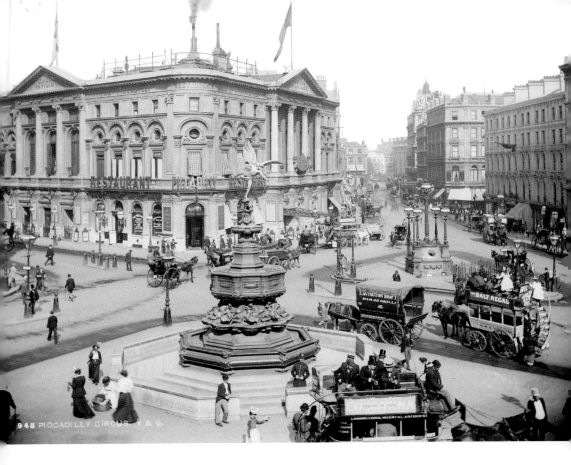

Eros, Piccadilly Circus

After the renowned Victorian philanthropist and social reformer Antony Ashley Cooper, 7th Earl of Shaftesbury, died in 1885, a public meeting decided to erect a marble statue in his honour in Westminster Abbey and another 'on a conspicuous site in one of the most frequented public thoroughfares in London'. The site eventually chosen was Piccadilly Circus. The sculptor commissioned was Albert Gilbert, who had trained in the Italian tradition but was influenced by the art nouveau movement. For the fountain Gilbert used bronze, but aluminium for the aerial figure. The supporting leg is solid, but the rest of the body hollow. The figure – officially named the Angel of Christian Charity – is commonly believed to be Eros, but is in fact his brother, Anteros, the god of requited love, reflecting the people's love for a man who so loved them. (Historic England Archive)

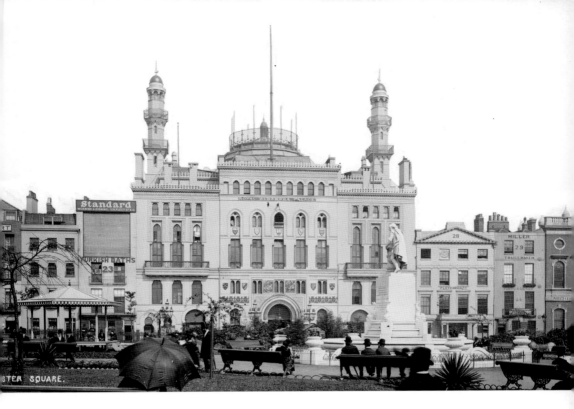

Above: Royal Alhambra Theatre, Leicester Square
This landmark building was designed by T. Hayter Lewis and opened in 1854 as the Panopticon of Science and Art, a venue for showcasing the arts, scientific demonstrations and popular education. It closed just two years later and was converted by Lewis into the Alhambra Palace, a theatre and music hall built in an opulent Moorish style, with lavish fenestration, two towers and a dome. The Alhambra building was replaced in 1937 by the Odeon, the largest single-screen cinema in the UK and the flagship of the Odeon cinema chain, which hosts numerous European and world film premieres throughout the year. (Historic England Archive)

Opposite above: Criterion Restaurant, Piccadilly Circus
The Criterion Restaurant was designed in the Neo-Byzantine style by Thomas Verity, a leading theatre architect of his day. Its frontage, built of Portland stone and suggestive of a French Renaissance influence, is regarded as the best surviving example of his work. The five-storey complex of dining rooms, ballroom, basement theatre and world-famous Long Bar opened in 1873 to immediate success. The east room was particularly popular with ladies shopping in Regent Street, but it was also the setting for many of the first afternoon tea meetings organised and held by Christabel Pankhurst as a part of the women's suffrage movement. (© Historic England Archive)

Opposite below: Criterion Theatre, Piccadilly Circus
The original plan was for a galleried concert hall in the basement, but after building work had already begun, it was decided to turn it into a theatre. The theatre initially struggled to obtain a licence to operate, because it was underground and lit by gas, giving rise to a risk of toxic fumes. Eventually a licence was issued, but fresh air had to be pumped into the auditorium to prevent the audience from being asphyxiated. Alterations to the theatre by Verity in 1883 included the replacement of gas lighting with electricity. (© Historic England Archive)

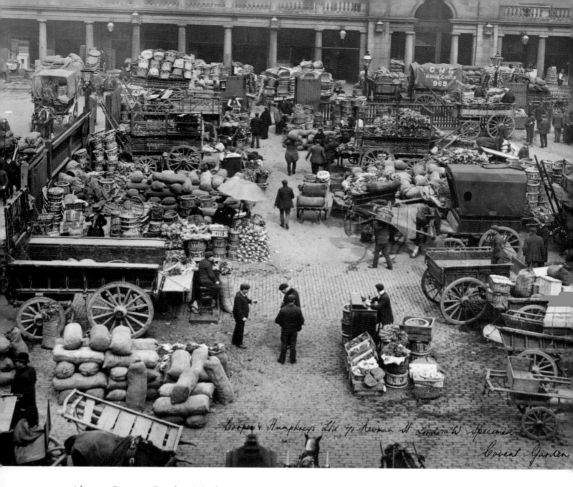

Above: Covent Garden Market

The name Covent Garden is a corruption of 'Convent Garden', a vegetable garden belonging to the monks at Westminster Abbey. In the 1630s, the 4th Earl of Bedford built a home for himself there and commissioned renowned architect Inigo Jones to develop a square of town houses. St Paul's Church was added almost as an afterthought, and has been a feature of the area ever since. The square was London's first piazza and the earl's role in its creation is commemorated today in Bedford Street. Markets gathered there from as early as 1656 and spread so rapidly that Charles II granted Covent Garden a royal charter in 1670. The Central Market was constructed in 1830 and it continued as a bustling fruit and vegetable market until it outgrew the site and was forced to move by an Act of Parliament to Nine Elms in South London in 1974. Covent Garden reopened in 1980 as a major tourist and shopping destination. (Historic England Archive)

Opposite: Royal Opera House, Covent Garden

The magnificent Royal Opera House, with its grand classical portico, is actually the third theatre to stand on the Covent Garden site. The first was built by the impresario John Rich with the proceeds from John Gay's *The Beggar's Opera*. Designed by Edward Shepherd, the Theatre Royal opened in 1732 and was primarily a playhouse. After the theatre was completely destroyed by fire, with the loss of twenty-three firemen, rebuilding of its replacement began in 1808 to designs by Robert Smirke. Fire struck again in 1856, and the theatre was once more completely destroyed. E. M. Barry's new building opened in May 1858 but, while the façade, foyer and auditorium date from this time, almost every other element of the present complex is a result of an extensive reconstruction in the 1990s. (Historic England Archive)

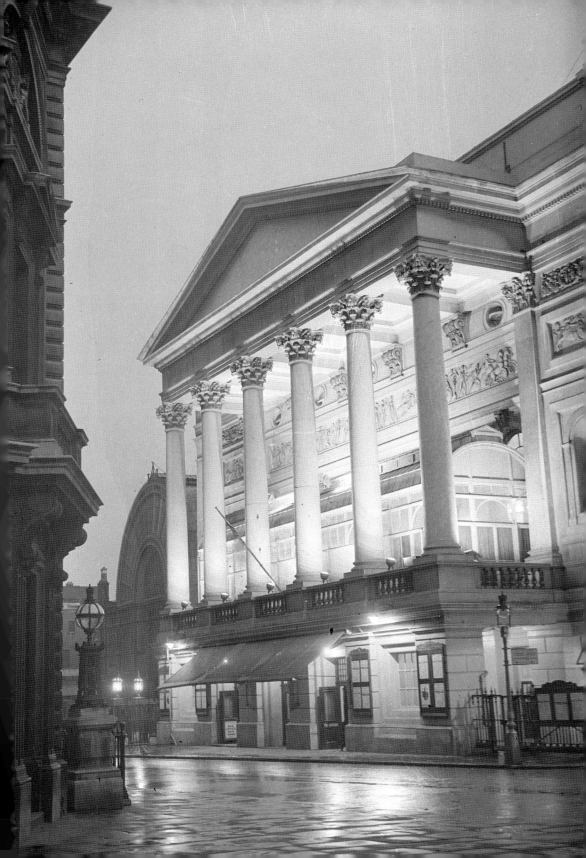

Regent's Park and Fitzrovia

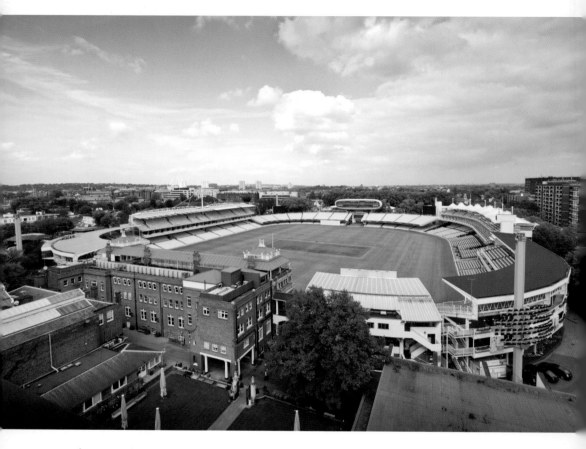

Above: Lord's Cricket Ground, St Johns Wood Road
As the headquarters of Marylebone Cricket Club (MCC), Middlesex County Cricket Club and the England and Wales Cricket Board, Lord's Cricket Ground can rightly claim to be the 'Home of Cricket'. Although it was built for the aristocrats and noblemen who played cricket nearby, it is actually named after its founder, Thomas Lord, an entrepreneur and cricketer. The current site is the third of three grounds that Thomas Lord established between 1787 and 1814. It is also home to the world's oldest sporting museum. (© Historic England Archive)

Opposite above: The Ashes Urn, MCC Museum
The Ashes were first referred to by the *Sporting Times* in a mock obituary of English cricket the day after England lost to Australia – for the first time on home soil – in 1882. While on tour in Australia later that year, England captain Ivo Bligh was given the small terracotta urn as a symbol of the ashes he hoped to regain. Bligh always regarded the urn as a personal gift and on his return to England he kept it on his mantelpiece at home in Kent. Only on his death in 1927 were they bequeathed to the MCC. (© Historic England Archive)

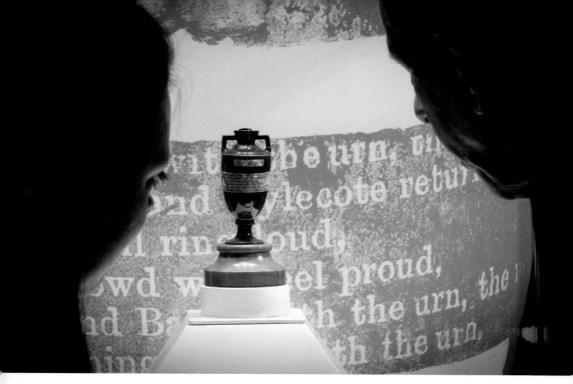

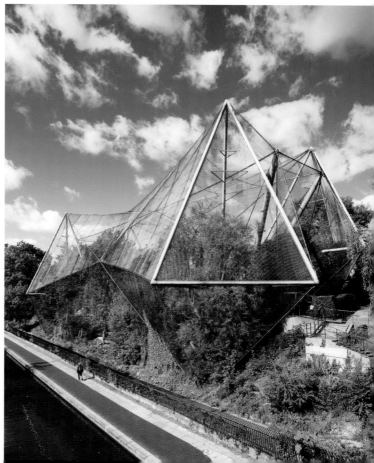

Right: Snowdon Aviary, London Zoo, Regent's Park London Zoo is the oldest zoo in the world, originally intended to be used for scientific study. Shortly after it opened in 1828 the animals of the Tower of London menagerie were transferred to the zoo's collection. Today it houses over 19,000 animals and more than 650 species. The zoo was eventually opened to the public in 1847. Designed by Lord Snowdon and Cedric Price (and named after Lord Snowdon), the aviary was built in 1962. Inspired by the graceful movements of flying birds, its frame makes pioneering use of aluminium to appear almost weightless. At the time of opening in 1965 it was Britain's first walk-through aviary. (© Historic England Archive)

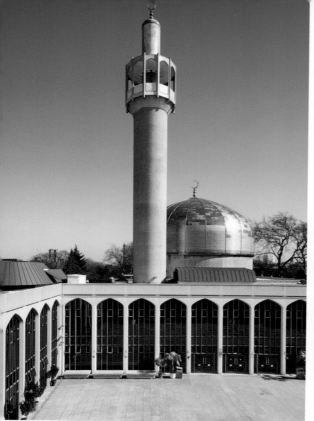
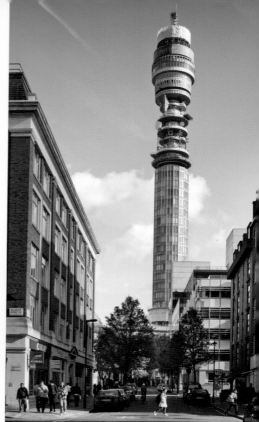

Above left: The Islamic Cultural Centre and London Central Mosque, Regent's Park
In 1944 the wartime government of Winston Churchill gifted a 2.3-acre site in Regent's Park to the Muslim community. The Islamic Cultural Centre was officially inaugurated by George VI in November 1944. In 1969 Sir Frederick Gibberd won an open international competition for the design of the London Central Mosque next to the centre. Construction began in 1974 and was completed in 1977 at a cost of £6.5 million. The main hall can accommodate over 5,000 worshippers. (© Historic England Archive)

Above right: BT Tower, Fitzrovia
The Post Office Tower was opened in 1965 by the then Prime Minister Harold Wilson. Designed by architects Eric Bedford and G. R. Yeats, with a height of 189 metres (620 feet) it was at the time the tallest building in the UK. It was commissioned to support microwave aerials to handle up to 150,000 simultaneous telephone conversations and forty television channel transmissions across the country. The building's cylindrical shape meant that it would shift no more than 20 centimetres (or one third of a degree) in high winds – vital for the aerials it carried. A rotating restaurant on the thirty-fourth floor called 'Top of the Tower' made one revolution every twenty-two minutes, and still does on special occasions. (© Historic England Archive)

British Library, Euston Road
The British Library was the largest public building constructed in the UK in the twentieth century, and it remains the largest library in the world with over 150 million items. Around 14 million of these are books; as a legal deposit library, it receives a copy of every publication produced in the UK and Ireland (approximately 8,000 per day). It was designed by Sir Colin St John Wilson and opened by the Queen in 1998. The large piazza in front includes sculptures by Eduardo Paolozzi and Antony Gormley. (© Historic England Archive. John Laing Collection)

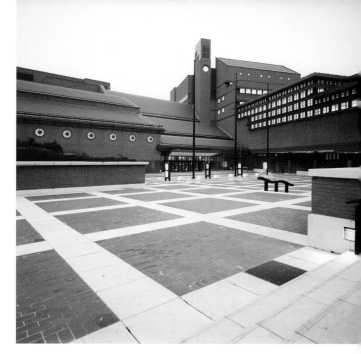

St Pancras Station, Euston Road
St Pancras station was designed and built by Midland Railway engineers William Henry Barlow and Roland Mason Ordish. When it opened in 1868, it had the largest single-spanned roof in the world, and its design was copied across the world, including Grand Central station in New York. The pointed arch of the roof is complemented by the architecture of the hotel and station accommodation, designed by George Gilbert Scott and completed in 1876. Between 2004 and 2007 the station was extended for use by Eurostar trains to continental Europe. The hotel was also remodelled to provide both hotel and residential accommodation. The hotel reopened on 5 May 2011, exactly 138 years after its original opening. (Historic England Archive)

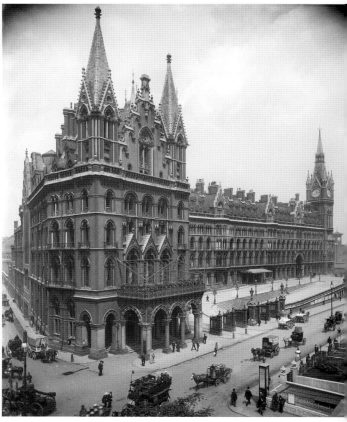

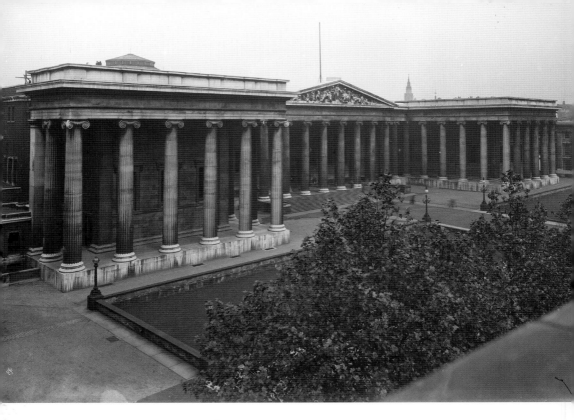

British Museum, Great Russell Street

The British Museum began with the bequest to the nation of a collection of more than 71,000 objects by the physician, naturalist and collector Sir Hans Sloane in return for a payment of £20,000 to his heirs. The gift was accepted and an Act of Parliament in 1753 established the British Museum. Four years later, George II donated the 'Old Royal Library', and the museum opened in 1759 in a seventeenth-century mansion, Montagu House, on the site of today's building. The growing collection required the building to be periodically extended, most notably in the second quarter of the nineteenth century by the building we see today, designed by Sir Robert Smirke, and more recently by the conversion of Smirke's central quadrangle into the Queen Elizabeth II Great Court – the largest covered square in Europe – which was designed by Foster & Partners and completed in 2000. Also in the interests of space, the natural history collections were moved to South Kensington in the 1880s, and the book collections to the British Library on a new site at St Pancras in 1998. The collection today totals over 8 million objects at the British Museum, around 70 million at the Natural History Museum and over 150 million at the British Library. (Historic England Archive)

City of London

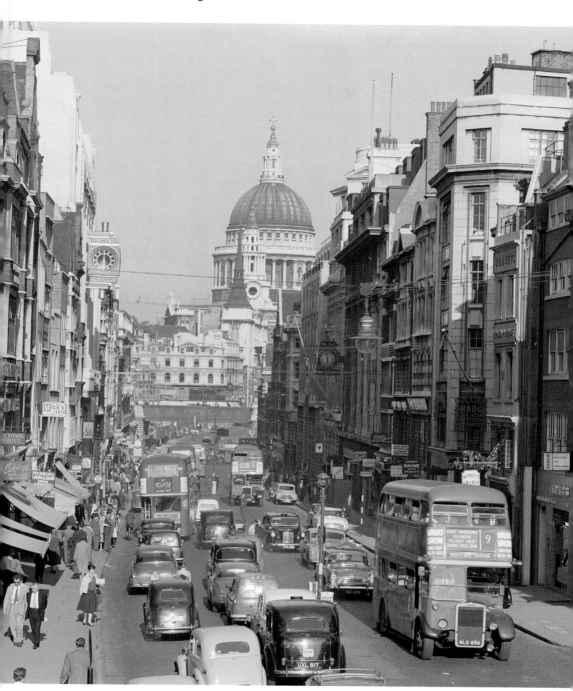

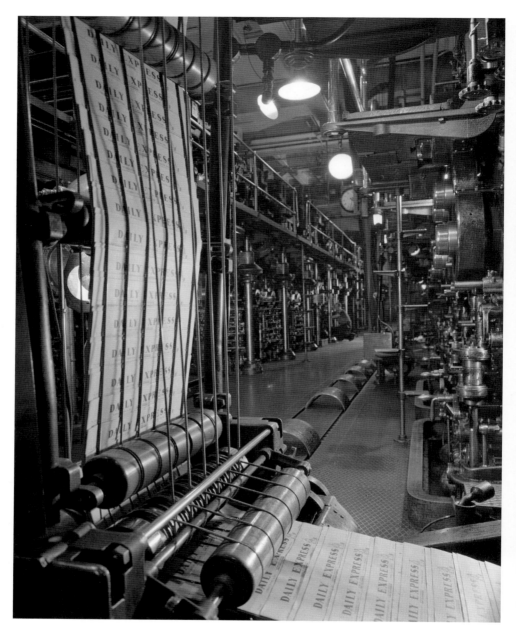

Above and previous: Fleet Street, and Printing Presses in the *Daily Express* Building
Fleet Street became known for printing and publishing at the start of the sixteenth century, mainly to supply the many law firms in the four Inns of Court nearby. London's first daily newspaper appeared two centuries later and the press became its principal trade so that by the twentieth century most British national newspapers operated from here. The *Daily Express* building was designed by architect Sir Owen Williams with Ellis and Clarke. Much of the industry moved out in the 1980s, but some former newspaper buildings have been preserved, and Fleet Street remains synonymous with the British national press. (© Historic England Archive)

Blackfriars Bridge, Southwark

Blackfriars Bridge from the west, with Canary Wharf in the background. This photo predates the recent redesign of the bridge, which was carried out in 2009–12. The station is now the only one with entrances on both sides of the Thames, and uses over 4,400 photovoltaic panels that generate up to 50 per cent of the station's energy. The piers of the original bridge remain (1862–64), by Joseph Cubitt and F. T. Turner. (© Historic England Archive)

St Paul's Cathedral

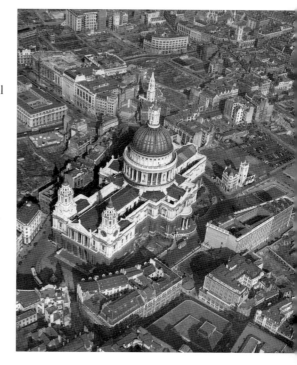

For more than 1,400 years, a cathedral dedicated to St Paul has stood on Ludgate Hill, the highest point in the City of London. After old St Paul's was destroyed in the Great Fire, Sir Christopher Wren was commissioned to design a new cathedral that was 'handsome and noble to all the ends of it and to the reputation of the City and the nation'. His English baroque masterpiece has dominated the London skyline for over 300 years. At 111 metres (365 feet) high, it was the tallest building in London until 1967, and the dome is still among the highest in the world. Construction began in 1675 and the cathedral was officially completed thirty-six years later, on Christmas Day 1711. St Paul's Cathedral has been the setting for many of the nation's most significant ceremonies including the funerals of Admiral Nelson, the Duke of Wellington and Sir Winston Churchill, jubilee celebrations for Queen Victoria and Elizabeth II, and the wedding of Charles, Prince of Wales, and Lady Diana Spencer. (© Historic England Archive. Aerofilms Collection)

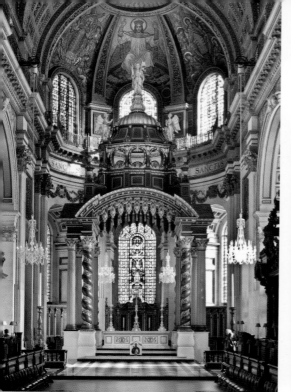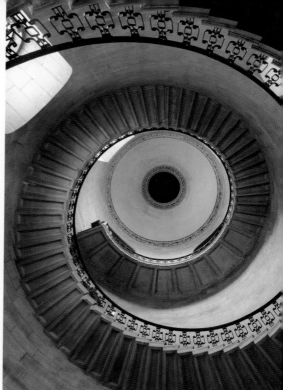

Above left: The Baldacchino, St Paul's Cathedral
The ornate Baldacchino (ceremonial canopy of state) replaced its bomb-damaged Victorian predecessor. It was designed by W. Godfrey Allen, surveyor to St Paul's Cathedral during the mid-twentieth century, and Stephen Dykes Bower, a British church architect and champion of the Gothic Revival style who was best known for restoring, repairing and maintaining the interior at Westminster Abbey. (© Historic England Archive)

Above right: Geometric Staircase, St Paul's Cathedral
The Geometric, or Dean's Stair, built in the south-west tower in 1705, is a spectacular stone spiral of eighty-eight Portland stone steps, which rise 15 metres (50 feet) from the cathedral floor to the triforium (arched gallery). The staircase was created by the mason and carver W. Kempster, and it was a feat of engineering. (© Historic England Archive)

Opposite above: Central Criminal Court, Old Bailey
The Central Criminal Court, popularly known as the Old Bailey, is named after the street on which it stands, and which follows the line of the original city wall – or 'bailey'. The location of the courthouse next to the then Newgate Prison was convenient for bringing prisoners to trial. After a fire in 1877, it was decided to demolish both the original court and the now dilapidated prison to make room for a larger building. This was designed by E. W. Mountford in the neo-baroque style and opened by Edward VII in 1907. The 20.5-metre- (67-foot-) high dome is crowned by a gold leaf statue of a 'lady of justice' holding a sword in one hand and the scales of justice in the other, by sculptor F. W. Pomeroy. Unlike similar representations of Justice, however, she is not blindfolded. (Historic England Archive)

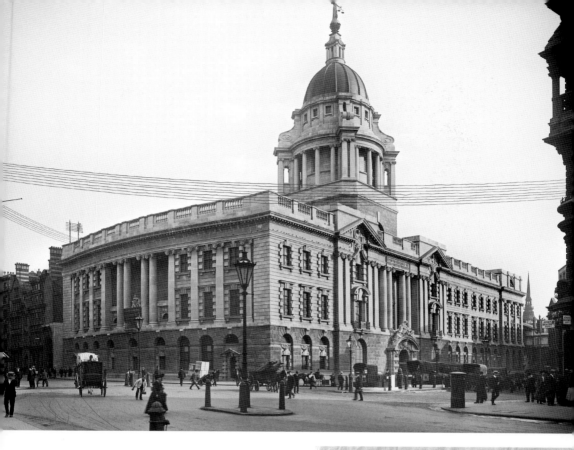

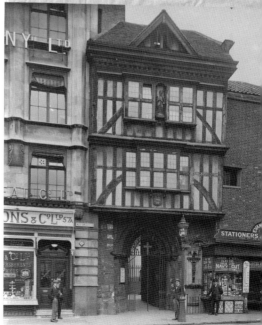

Right: Gatehouse of Church of St Bartholomew the Great

This jettied gatehouse was built in 1595 and restored in 1916 by Philip Webb, who added the gable and shallow oriel. The gateway incorporates a thirteenth-century door to the south nave of the church. The church itself is the surviving eastern portion of the Augustian priory that was founded in 1123, the most important twelfth-century monument in London, although much altered and rebuilt.

Left: The Gatehouse to
St Bartholomew's Hospital
St Bartholomew's Hospital, known simply as
Barts, was originally founded in 1123 by Rahere,
a favourite courtier of Henry I, and is the oldest
hospital in London. Concerned for the sick and
poor after the Dissolution of the Monasteries,
which removed the hospital's funding, the citizens
of London petitioned Henry VIII for the grant
of four hospitals in the City. Shortly before
his death, the king refounded the hospital and
endowed it with properties and income. A statue
of Henry VIII by Francis Bird was consequently
placed in the gateway to the hospital, built by
Edward Strong in 1702. The hospital itself was
rebuilt to designs by James Gibbs between 1729
and 1770. In the early 1990s the hospital was
deemed unviable, but after a public petition
collected over 1 million signatures, in 1998 the
government decided that Barts would become a
specialist cancer and cardiac hospital. (Historic
England Archive)

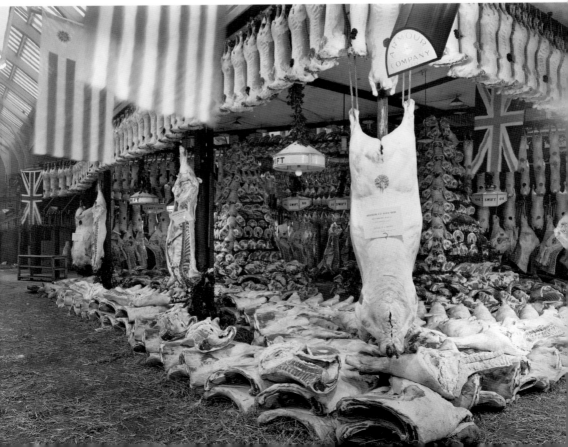

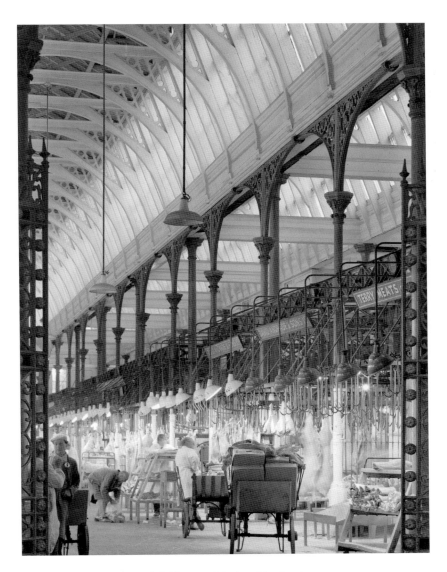

Above and opposite below: Smithfield Meat Market, Farringdon

A livestock market occupied the broad grassy area known as Smooth Field from the tenth century. It grew with the city so that by the mid-nineteenth century 220,000 cattle and 1.5 million sheep were sold there each year. Many were slaughtered on-site – a grisly scene that Charles Dickens described in Oliver Twist. Nor was it only animals who met their end in Smithfield: the Scottish patriot Sir William Wallace ('Braveheart'), and Wat Tyler, leader of the Peasants' Revolt, were both executed there, as were more than 200 Protestant martyrs during the reign of 'Bloody' Mary I. In 1855 the 'live' market was moved to Copenhagen Fields in Islington. The present-day Central Market opened in 1868 and was designed by Horace Jones, who went on to design Billingsgate Market (1875), Leadenhall Market (1881) and Tower Bridge (completed after his death in 1887). Today, Smithfield is the last surviving historic wholesale market in Central London, supplying butchers, shops and restaurants in the city centre with quality fresh meat. (© Crown copyright. Historic England Archive; Historic England Archive)

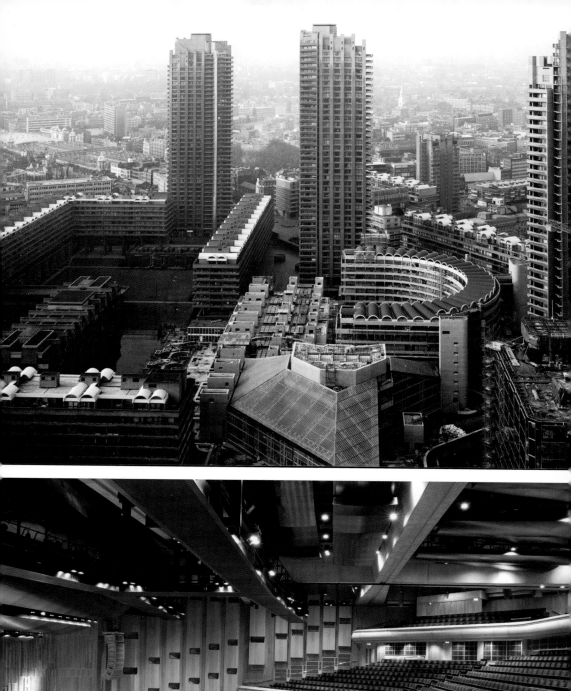
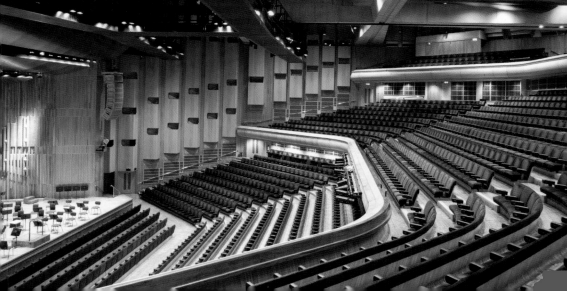

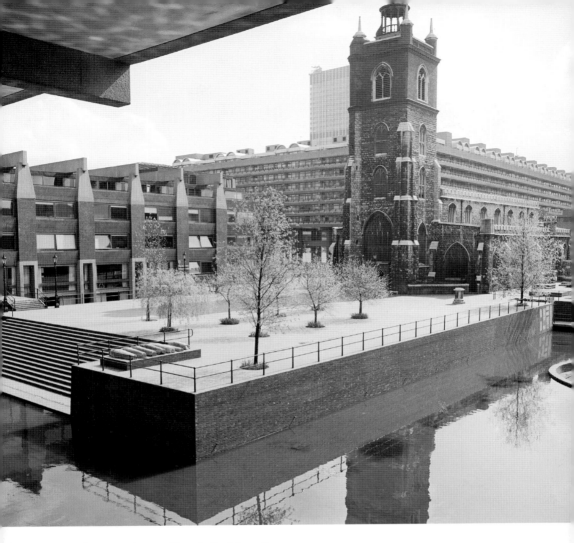

Above: St Giles' Cripplegate Church, Barbican Centre
A church is believed to have stood on this site for 1,000 years. In 1090, a Norman church built by Alfune, Bishop of London, replaced the earlier Saxon structure, and it was dedicated to St Giles during the Middle Ages. Cripplegate refers to one of the gates through the old city wall, 'cruplegate' meaning a 'covered way or tunnel', which would have run from the gate to the original Barbican, a fortified watchtower on the city wall. The church was damaged during the Second World War, but at the end of the war was one of only a few buildings in the area still standing. (© Historic England Archive)

Opposite above and below: Barbican Centre, Silk Street
By the end of the nineteenth century, Barbican Street was the centre of the London rag trade and home to fabric and leather merchants, furriers, glovers and similar tradespeople. However, the area was almost completely razed to the ground in the Blitz during the Second World War. Redevelopment work began in 1962 to designs by architects Chamberlin, Powell and Bon, and was carried out over six phases. The fifth of these was the construction of the Barbican Arts Centre, which began in the early 1970s and was opened by the Queen in 1982. The Barbican is one of London's best examples of Brutalist architecture. (© Historic England Archive. John Laing Collection; © Historic England Archive)

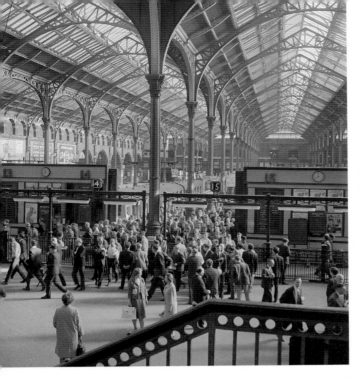

Left: Liverpool Street Station
The station opened in 1874 as
the Great Eastern Railway's main
London terminus, and by the
following year it had the largest
number of platforms on any
terminal railway station in London.
Designed by Edward Wilson, and
built of wrought iron and glass
rising high above, the station was
nicknamed the 'dark cathedral'.
The current light and spacious
concourse was created as part of a
1980s redevelopment. (© Historic
England Archive)

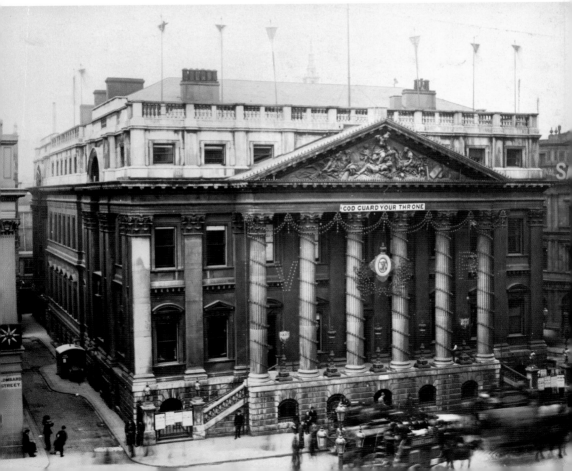

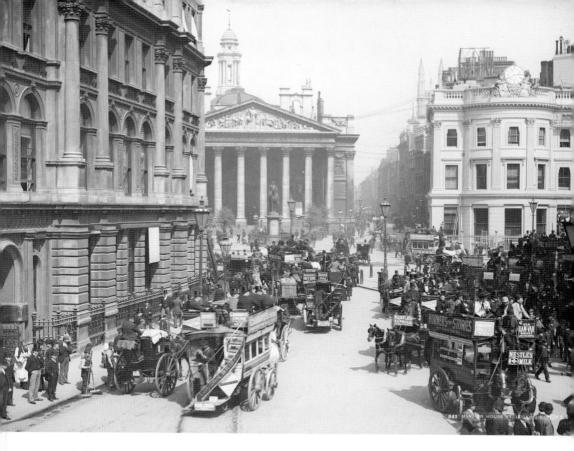

Above: The Royal Exchange, Bank

The wealthy merchant Sir Thomas Gresham established the Royal Exchange (in the centre of this picture) in 1566 as London's first purpose-built centre for trading stocks. It was modelled on the world's oldest financial exchange, the Bourse in Antwerp, from where some of the building materials were imported. The original building was destroyed in the Great Fire of London and rebuilt three years later in a baroque style by city surveyor Edward Jerman. After this too was destroyed by fire in 1838, an architectural competition to design the third (and current) Royal Exchange was won by Sir William Tite. Tite retained the original layout, but installed an imposing entrance inspired by the Pantheon in Rome. The interior was designed by Edward L'Anson, making early use of concrete and adorned with pediment sculptures by Richard Westmacott (the younger). The Grade I-listed building was extensively remodelled into a luxury shopping and dining destination in 2001 by architects Aukett Fitzroy Robinson. The gilded copper grasshopper weathervane is emblematic of the Gresham family crest. (Historic England Archive)

Opposite below: Mansion House

Mansion House is the official residence of the Lord Mayor of London. It was built between 1739 and 1752 by the surveyor and architect George Dance the Elder in the then fashionable Palladian style, with three main storeys over a rusticated basement. The entrance façade has a portico with six Corinthian columns, supporting a pediment with a tympanum sculpture by Sir Robert Taylor, in the centre of which is a symbolic figure of the City of London trampling on her enemies. It also has eleven holding cells including one for women – the 'birdcage' – in which the suffragette campaigner Sylvia Pankhurst was once held. (Historic England Archive)

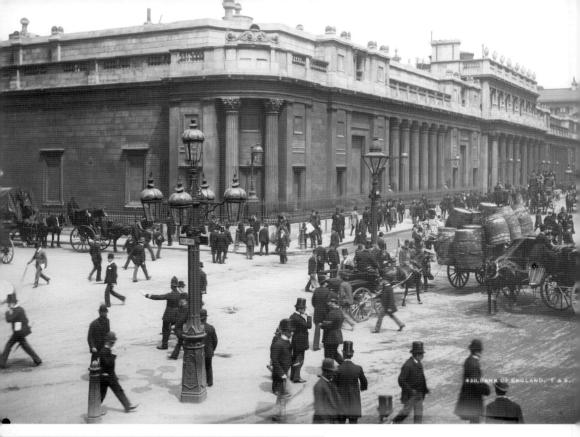

Above and left: Bank of England, Threadneedle Street

The Bank of England was founded as a private bank in 1694 to act as banker to the government. In 1734, it moved from Cheapside into the UK's first purpose-built bank on the present site in Threadneedle Street. Sir John Soane, one of the UK's greatest architects, began his career by doubling the size of the bank to 3.5 acres, and enclosing it in 1828 with the windowless wall that stands to this day. 'Soane's Bank' is shown in the image above. Its replacement was designed by Sir Herbert Baker between 1925 and 1939, and was described by the architectural historian Nikolaus Pevsner as 'the greatest architectural crime, in the City of London, of the twentieth century'. The bank is custodian to the official gold reserves of the United Kingdom and around thirty other countries. Around 400,000 bars are held in a vast underground vault that requires 0.9-metres- (3-foot-) long keys to open. (Historic England Archive; © Historic England Archive)

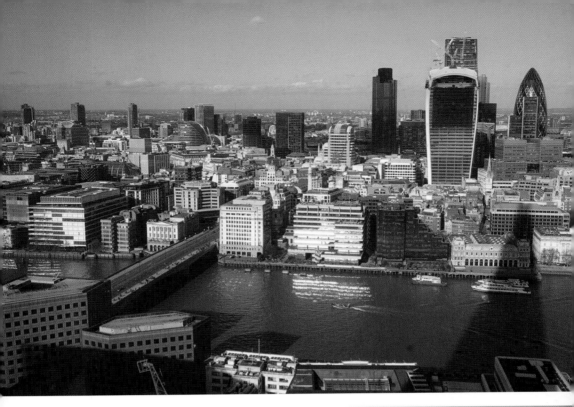

Above: The Barbican and the City
A view north across London Bridge towards the City and the Barbican, to the left in the distance. (Author's collection)

Right: Gibson Hall with Tower 42, Bishopgate
The hall was designed as the head office for the National Provincial Bank by John Gibson, a former assistant to Sir Charles Barry who built the Houses of Parliament. The building, which opened in 1865, is a fine example of Victorian neoclassical banking architecture, and is widely regarded as Gibson's finest work.

The National Provincial Bank was one of three banks that merged to form the National Westminster Bank. The NatWest Tower was designed by Richard Seifert and built between 1971 and 1980 as the bank's international headquarters. Seen from above, the shape of the tower resembles that of the NatWest logo (three chevrons in a hexagonal arrangement). It was the tallest building in the UK until 1990. After the tower was severely damaged by a bomb in the April 1993, it was refurbished, then sold and renamed. (© Historic England Archive)

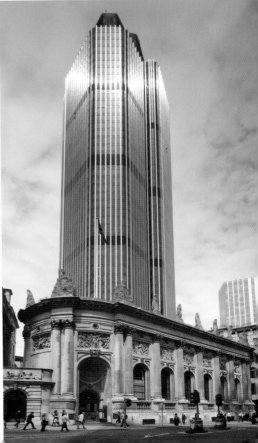

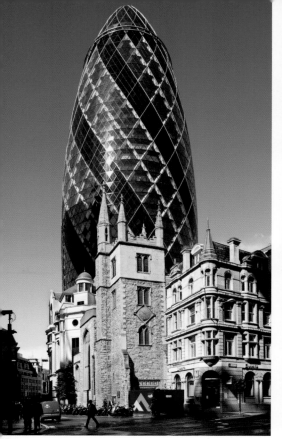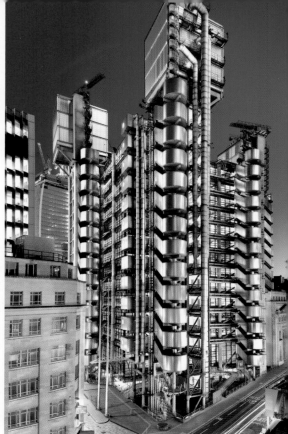

Above left: 'The Gherkin', No. 30 St Mary Axe
The 180-metre- (591-foot-) tall office building stands on the former sites of the Baltic Exchange and Chamber of Shipping, which were extensively damaged by a bomb in 1992. Nicknamed the Gherkin, it was designed by Foster & Partners, completed in December 2003 and opened on 28 April 2004. (© Historic England Archive)

Above right: Lloyds Building, No. 1 Lime Street
Home to the insurance market Lloyds of London, the building was designed by Richard Rogers and is a leading example of radical Bowellism architecture in which the services for the building, such as ducts and lifts, are located on the exterior to maximise space inside. For this reason, it is also known as the 'Inside-Out Building'. It was completed in 1986 and awarded a Grade I listing in 2011, the youngest structure ever to obtain this status at the time (although the British Library is now the youngest to be Grade I listed). Historic England consider it to be 'universally recognised as one of the key buildings of the modern epoch'. (© Historic England Archive)

Guild Church of St Margaret Pattens and the 'Walkie-Talkie'

A church was first recorded on the site in 1067. It was rebuilt in 1538 but was destroyed in the Great Fire of London in 1666, and the present church was built by Sir Christopher Wren in 1687. It is dedicated to St Margaret of Antioch and its name is said to derive from pattens, the wooden-soled overshoes worn to protect pedestrians from the muddy City streets, which were left outside on the steps of the church by worshipers.

Designed by Rafael Viñoly, the building at No. 20 Fenchurch Street is informally known as the 'Walkie-Talkie' because its highly distinctive top-heavy shape resembles that of the handheld two-way radio transceiver with the same nickname. At 160 metres (525 feet), it is more than 2.5 times the height of the church spire beneath. (Author's collection)

Pedestal, The Monument, Monument Street

The monument to the Great Fire of London was designed by Sir Christopher Wren and Robert Hooke and erected between 1671 and 1677. The fire began in the kitchens of the king's baker, Thomas Farriner, on Pudding Lane on 2 September 1666. It raged for four days, destroying one third of all buildings in London and making 130,000 people homeless. The monument is the tallest isolated stone column in the world, with a height of 61.5 metres (202 feet) – the exact distance to where the fire began in Pudding Lane. (Historic England Archive)

Left: Billingsgate Fish Market, Lower Market Street

Originally a general market, an Act of Parliament in 1699 made Billingsgate 'a free and open market for all sorts of fish'. The only exception to this was the sale of eels, which was restricted to Dutch fishermen moored in the Thames as a reward for feeding the people of London during the Great Fire. Fish and seafood were sold from stalls and sheds around the 'hythe', or dock, but by 1850 the volume of fish traded had grown so much that a market building was erected on Lower Thames Street. This soon proved inadequate and it was demolished in 1873 to make way for the building designed by the city architect Sir Horace Jones, which stands there today. This photograph was taken outside. The market was relocated to the Docklands in 1982. (© Historic England Archive)

Below: Tower of London, Tower Hill

The Tower of London was built as part of the Norman Conquest of England. It takes its name from the central White Tower, set within two concentric rings of defensive walls and a moat, built by William the Conqueror in 1078. An early royal residence, the Tower has served variously as an armoury, a treasury, a menagerie, the Royal Mint, a public record office, and the home of the Crown Jewels of England. However, its popular reputation is as a prison and place of execution. It served as the former from 1100 until 1952. It is particularly notorious for the imprisonment of the young Princes in the Tower in the late fifteenth century, and of Elizabeth I (before she became queen) and Sir Walter Raleigh the following century. In spite of its enduring reputation as a place of torture and death, however, only nineteen people are known to have been executed within the Tower – twelve of whom were for espionage in the First and Second World Wars. (Historic England Archive)

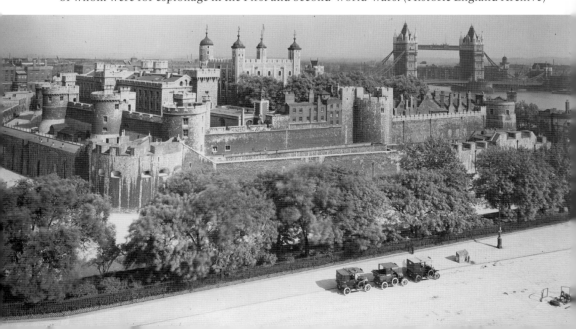

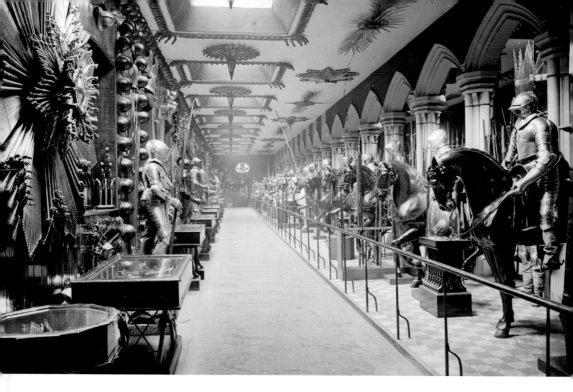

Above: Horse Armoury, Tower of London
There has been an armoury at the Tower almost from the time it was built. This collection of armour dates from the reign of Henry VIII. (Historic England Archive)

Overleaf: Tower Bridge
A new river crossing downstream of London Bridge was needed from the middle of the nineteenth century, but because a traditional fixed bridge would cut off access by sailing ships to the port facilities in between, a design was not approved until 1884. An Act of Parliament in 1885 specified that the bridge had to have an opening span with clearance of 61 metres (200 feet), headroom of 41 metres (135 feet), and built in a Gothic style. Sir John Wolfe Barry was appointed engineer with Sir Horace Jones as architect. Construction started in 1886 and took eight years, involving five major contractors and 432 construction workers. The bridge was opened by the Prince of Wales (the future Edward VII) on 30 June 1894.

Barry designed a bascule bridge with two bridge towers, which were 65 metres (213 feet) high, and built on piers made from 70,000 tonnes of concrete and sunk into the riverbed. Over 11,000 tonnes of steel provided the framework for the towers and upper-level walkways. This was clad in Cornish granite and Portland stone, to protect it and to make the bridge more attractive. After Jones died in 1886, George D. Stevenson took over the project. He replaced Jones's original brick façade with a more distinctive Victorian Gothic style intended to harmonise with the Tower of London.

The central span is 240 metres (800 feet) in length and split into two equal bascules or leaves, weighing over 1,000 tonnes each. These can be raised in five minutes up to an angle of 86 degrees to allow river traffic to pass, but are only raised to an angle sufficient for the vessel to pass safely under the bridge, except in the case when the monarch is on board, in which case they are raised fully no matter the size. River traffic is much reduced these days, but the bascules are raised around 1,000 times a year, and still takes priority over road traffic. (Historic England Archive; © Historic England Archive. Aerofilms Collection)

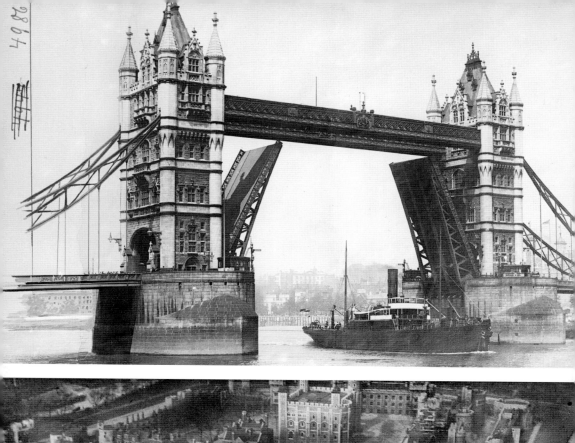

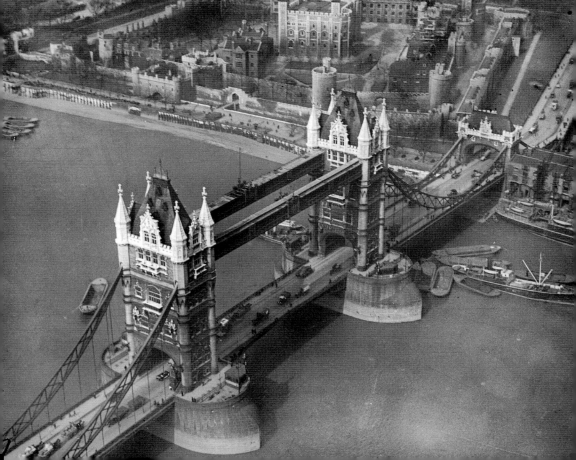

East London

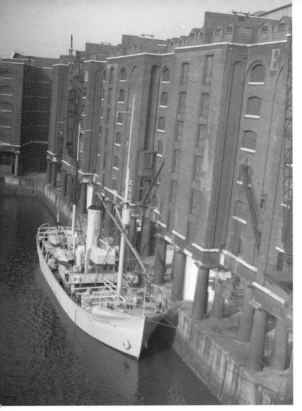

Left and previous: St Katherine's Dock, Wapping

These docks are named after a medieval hospital that stood on the site from the twelfth century. An Act of Parliament in 1825 cleared the way for the demolition of the hospital and neighbouring slums for redevelopment. The docks were designed by Thomas Telford, in his only major project in London, as two linked basins (East and West) to create as much quayside as possible. Steam engines designed by James Watt and Matthew Boulton kept the water level in the basins around 4 feet above that of the tidal Thames.

Because of their inability to cope with larger modern ships, the docks were among the first to be closed, in 1968. Since then, they have been extensively redeveloped into a popular leisure destination, including offices, housing, a large hotel, shops and restaurants, and The Dickens Inn, a former brewery dating back to the eighteenth century. The docks themselves have become a yachting marina. (Historic England Archive)

Columbia Road Flower Market

Columbia Road Market is London's principal flower market, and is open on Sunday mornings. It was built in an area known as Nova Scotia Gardens, an old brick field that by 1840 had degenerated into a notorious slum. The Victorian philanthropist Angela Burdett-Coutts purchased the land for a covered food market with 400 stalls in 1869, and it was named in honour of a bishopric she established in British Columbia. The flower market was introduced by French Protestant immigrants, but as the Jewish population grew a Sunday market was established. From the 1960s, the market enjoyed a new resurgence with the increasing popularity of gardening programmes. (© Historic England Archive)

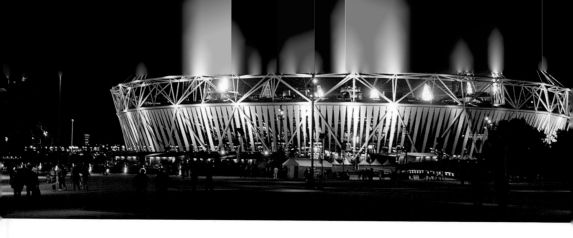

Above: London Stadium, Stratford
London Stadium was built for the 2012 Summer Olympic and Paralympic Games on an 'island' of former industrial land between the River Lea, City Mill River, Old Pudding Mill River, and St Thomas' Creek. The stadium was designed by Populous, a global architectural firm specialising in the design of sports facilities, arenas and convention centres. Construction began in 2008 and was completed three years later. After the 2012 Olympics, the stadium was remodelled into a multipurpose stadium, with West Ham United Football Club and British Athletics as its primary tenants. (Author's collection)

Below: *ArcelorMittal Orbit*, Queen Elizabeth Olympic Park
Designed by sculptor Sir Anish Kapoor and engineer Cecil Balmond, the extraordinary looping structure of the *ArcelorMittal Orbit* became symbolic of the playfulness of the 2012 London Olympic and Paralympic Games. The UK's tallest sculpture, 130,000 visitors during the Games enjoyed its 20-mile views over the London skyline. (Author's collection)

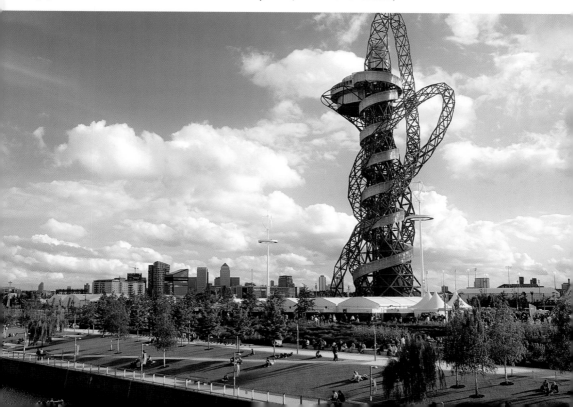

Greenwich and Bermondsey

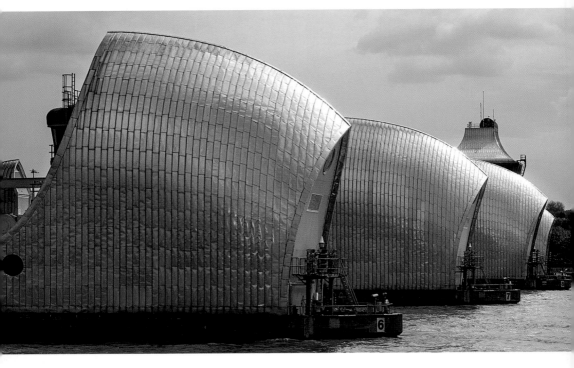

Above: Thames Barrier

The Thames Barrier was built in response to the 1953 North Sea flood, one of the UK's worst natural disasters that resulted in over 500 British deaths on land and at sea. The barrier divides the river into four 61-metre (200-foot) and two 30-metre (100-foot) navigable spans. The floodgates themselves are circular and rotate up from the riverbed when floods threaten. The concept of the rotating gates was devised by (Reginald) Charles Draper in 1969, based on the design of the taps on his gas cooker. Construction began in 1974 and the barrier was officially opened by Elizabeth II ten years later. (Alan Roland-Price)

Opposite above and below: The Millennium Dome

The Millennium Dome is located in Greenwich, home to Greenwich Mean Time (GMT), the international civil time standard until 1972. For this reason, the Dome was built as a large circular marquee, 365 metres in diameter (one metre for each day of a standard year). The canopy is made of PTFE-coated glass fibre fabric and is 52 metres high in the middle – one metre for each week of the year, supported by twelve 100-metre- (330-foot-) high yellow towers – one for each hour. The Dome was built to celebrate the arrival of the third millennium in 2000. The architect was Richard Rogers, noted for his modernist and functionalist designs in high-tech architecture, and the structure was engineered by Buro Happold.

Today, the Dome is an entertainment venue that includes the O2 Arena, which opened in 2007 with a concert by rock band Bon Jovi, and surpassed New York City's Madison Square Garden as the world's busiest music arena the following year. (Alan Roland-Price; © Historic England Archive)

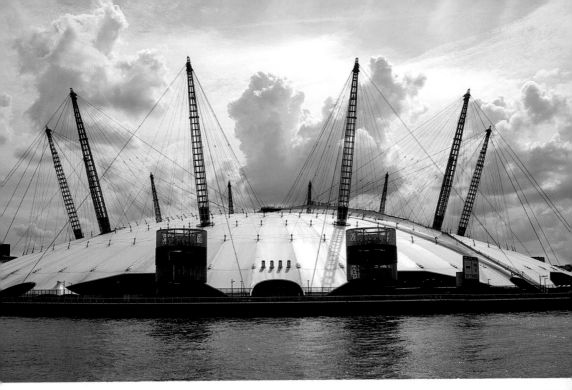

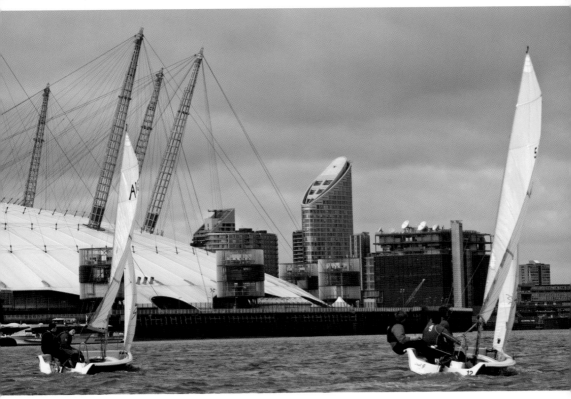

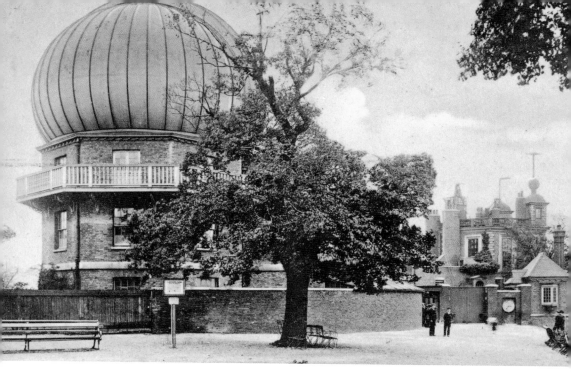

Above: Royal Observatory, Greenwich Park

The Royal Observatory stands on the Prime Meridian, the line of 0° longtitude that divides the earth into eastern and western hemispheres. The original building was commissioned in 1675 by Charles II and designed by Sir Christopher Wren. John Flamsteed was appointed as the first Astronomer Royal and director of the observatory, and as a result the building was often referred to as 'Flamsteed House'. The scientific work of the observatory was moved out in stages during the first half of the twentieth century, and the building has been a museum since 1960. Since then, the Prime Meridian has been marked by a brass (later stainless steel) strip in the observatory's courtyard, and from 1999 by a powerful green laser shining north across the London night sky. (Historic England Archive; Alan Roland-Price)

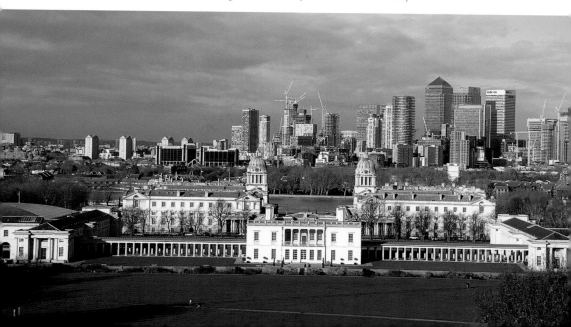

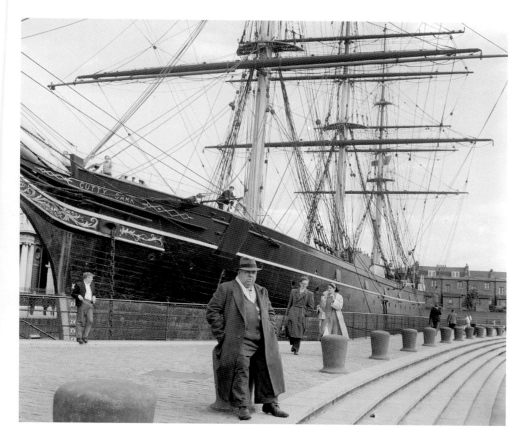

Above: Cutty Sark, Greenwich

The *Cutty Sark* was one of the last and fastest British tea clippers. However, she was built in 1869, the same year that the Suez Canal opened, providing steamships with a much shorter route to China. She was reassigned to transport wool from Australia, for which she held the record for the shortest sailing to Britain for ten years. She became an auxiliary cadet training ship in 1938, but by 1954 had reached the end of her sailing life and was transferred to permanent dry dock at Greenwich for public display as a museum ship. She was damaged by fire in 2007 while undergoing conservation, and again survived a smaller fire in 2014. Today, the *Cutty Sark* is one of only three remaining original composite construction (wooden hull on an iron frame) clipper ships from the nineteenth century. (© Historic England Archive)

Opposite below: Old Royal Naval College, Greenwich

The Old Royal Naval College is built over the site of Greenwich Palace, arguably the most important royal residence throughout the Tudor period, and the birthplace of Henry VIII, Elizabeth I and Mary I. A century later, James II first entertained the idea of establishing a home there for 'impotent Sea Commanders', but it was his daughter, Mary II, for whom a naval hospital became 'the darling object of her life'. Mary died of smallpox in 1694, eighteen months before even the foundations were laid, but her husband, William III, ordered that the royal charter founding the hospital predate her death so it could be issued in both their names. The first buildings for the hospital were overseen by Sir Christopher Wren, but it was only completed in 1751. In 1873 the hospital buildings were acquired for the Royal Naval College, until it closed in 1997. (Author's collection)

Above and below: Thames Tunnel

The Thames Tunnel was the first tunnel built beneath a navigable river. In just three months after it opened in 1843, it received one million visitors and was hailed the Eighth Wonder of the World. It was built to enable the Thames to be crossed without hindering the 3,000 tall-masted ships that sailed along that stretch of the Thames every day. It was designed and built by Sir Marc Isambard Brunel, who invented the Miners' Cage, or tunnelling shield, that allowed work to progress, albeit at a rate of only 3–4 metres (8–12 feet) a week. The tunnel flooded five times during construction, and in the worst flood in 1828 his son, Isambard Kingdom Brunel, barely escaped with his life.

The East London Railway bought the tunnel in 1865, and four years later trains first ran through it. In 1913 the railway was electrified and incorporated into the London Underground as the East London Line, making the Thames Tunnel the oldest tunnel in the oldest underground system in the world. The Thames Tunnel is now part of the London Overground. In 2016 the entrance hall opened as an exhibition space, with a staircase to the shaft for the first time in over 150 years. (Historic England Archive; Tate Harmer)

Southwark

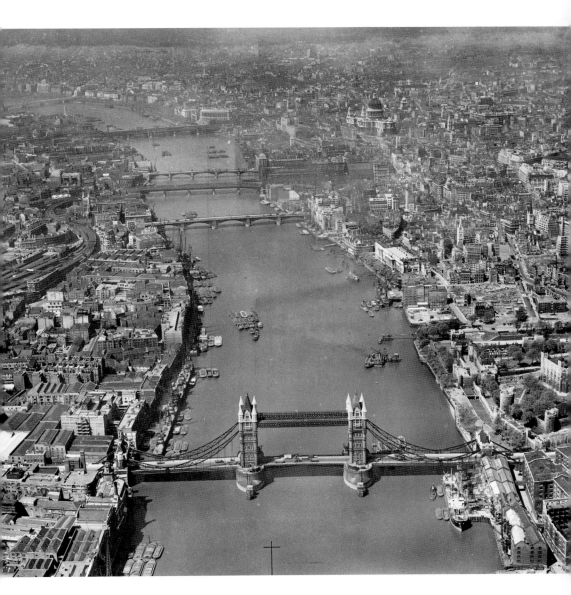

Tower Bridge
A view west along the River Thames towards Tower Bridge. (© Historic England Archive.
Aerofilms Collection)

Tower Bridge Hotel, Tower Bridge Road
This hotel was designed by Latham Augustus Withall OBE, a British architect who previously practised in Adelaide, Australia, where he designed the Adelaide Arcade and the Jubilee Exhibition Building. The hotel takes its name from Tower Bridge, which was being built at the same time. It later became the 'Pommeler's Rest' public house, taking its name from the area's centuries-old connection with the leather trade. A pommeler is someone who pummels, and a pommel is the protuberant part at the front of a saddle – both of which are associated with leather workers. (Historic England Archive)

City Hall, More London
Despite its name, City Hall neither lies in nor serves the City of London, but is instead the headquarters of the regional Greater London Authority, comprising the Mayor of London and the London Assembly. It was designed by Foster & Partners, and the 500-metre (1,640-foot) helical walkway that ascends all ten storeys inside to symbolise transparency is strongly reminiscent of Foster's design for the rebuilt Reichstag in Berlin. (© Historic England Archive)

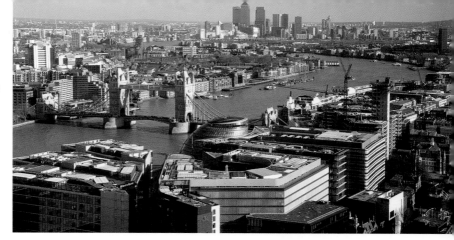

More London and Tower Bridge A view eastward over More London, a privately owned development on the south bank of the River Thames, and Tower Bridge. (Author's collection)

HMS *Belfast*
HMS *Belfast* is the first Royal Navy ship named after the capital city of Northern Ireland, and was launched on St Patrick's Day 1938. During the Second World War, she played a key role in the Arctic Convoys, the Battle of North Cape and the D-Day Normandy landings. She then served in the Far East, and was one of the first British ships to go into action in the Korean War. Marked for scrapping, she was saved through the efforts of the HMS Belfast Trust and brought to her present mooring on the Thames. She opened to the public as a museum ship in 1971, and became a branch of the Imperial War Museum in 1978. (Alan Roland-Price)

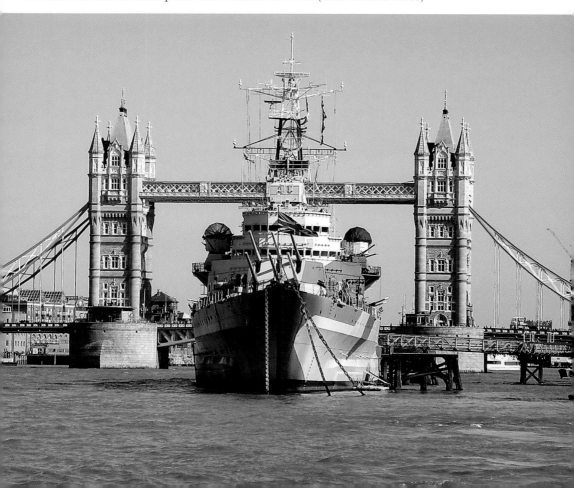

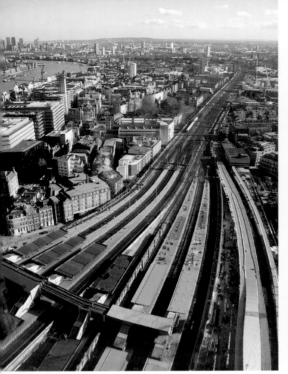

Above left and right: Railway Lines and the Shard, London Bridge

Standing 310 metres (1,016 feet) high, the Shard is the tallest building not only in the UK but also the European Union. The tower has seventy-two habitable floors, capped with a viewing gallery and open-air observation deck at a height of 244 metres (801 feet). The Italian architect and engineer Renzo Piano was inspired by the railway lines and masts of sailing ships around the base of the tower. The building features 11,000 panes of glass with a total surface area of 56,000 square metres (over 600,000 square feet) intended to reflect the sky and sunlight above the tower, so that its appearance changes with the weather. The former Church of St Thomas is in the foreground, which was originally part of St Thomas's Hospital and still retains a (largely reconstructed) nineteenth-century operating theatre in its attic. The church was constructed in around 1702– 03. (Author's collection; © Historic England Archive)

Left: George Inn, Borough High Street

The George Inn is a *c.* seventeenth-century galleried coaching inn that is now owned and leased by the National Trust. It is London's sole surviving example of this type of inn, which were often used in Elizabethan England to stage plays. The partly timber-framed building was rebuilt in 1677 after a serious fire that destroyed most of medieval Southwark. The ground floor is divided into a number of interconnected bars, of which the Parliament Bar was the waiting room for coach passengers. The Middle Bar was the coffee room, frequented by Charles Dickens, who refers to it in *Little Dorrit*. (Historic England Archive)

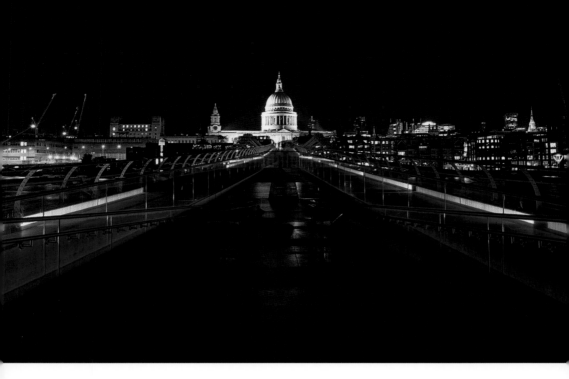

Above: Millennium Bridge, Southwark
The London Millennium footbridge is a steel suspension bridge over the Thames. The innovative 'blade of light' design from Arup Group, Foster & Partners, and Sir Anthony Caro has the supporting cables below the deck level, giving the bridge a very shallow profile and pedestrians an enhanced view. The bridge opened in June 2000 but closed just two days later because of excessive swaying motion, caused by pedestrians walking in step. The 'Wobbly Bridge', as it became nicknamed, was closed for almost two years while modifications were made to eliminate the motion. It reopened in 2002. (Alan Roland-Price)

Overleaf above: Shakespeare's Globe, New Globe Walk
Shakespeare's original theatre (not sited on the banks of the Thames as today) was built in 1599, rebuilt in 1614 following a fire and finally demolished in 1644. In 1970, American actor and director Sam Wanamaker set out to recreate the Globe. The Thames was much wider in Shakespeare's time and the original site is around 230 metres (750 feet) further inland today, but the new Globe was reconstructed on the riverbank to recreate the atmosphere of the original theatre. The design and the materials used in the reconstruction were painstakingly researched and are as accurate as modern scholarship can determine. The building itself is constructed entirely of English oak and it has the first and only thatched roof permitted in London since the Great Fire of 1666 (although the current construction is outside of seventeenth-century London). Modern-day health and safety requirements, however, mean that it can entertain only around half of the original theatre's audience of 3,000. (© Historic England Archive)

Imperial War Museum
The Imperial War Museum was established in 1917 to record the civil and military war effort and sacrifice of Britain and its empire during the First World War, even before the war had ended. Its remit has since been expanded 'to provide for, and to encourage, the study and understanding of the history of modern war and wartime experience'. The museum opened to the public in 1920 in the Crystal Palace at Sydenham Hill, South London. It moved just four years later to the Imperial Institute in South Kensington, and finally in 1936 to its present home in the former Bethlem Royal Hospital. The hospital still exists as an institution and is a major centre for research in psychiatric health. (Imperial War Museum)

Lambeth

The Old Vic Theatre, The Cut
This theatre was established in 1818 by James King and Daniel Dunn as the Royal Coburg Theatre, after Prince Leopold of Saxe-Coburg-Saalfeld, the future king of Belgium and uncle to both Queen Victoria and Prince Albert. It was renamed the Royal Victoria Theatre in 1833, the Royal Victoria Palace after it was rebuilt in 1871, and the Royal Victoria Hall from 1880. By this time, however, it was already known as the 'Old Vic'. The theatre was damaged during air raids in 1940, and was made a Grade II*-listed building after it reopened in 1951. The theatre celebrated its bicentenary in 2018. (Historic England Archive)

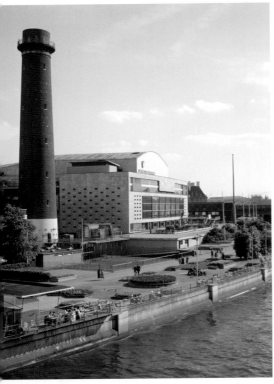

Left and below: Royal Festival Hall
The Lion Brewery was built in 1836, closed in 1924 and the buildings demolished in 1949 to make way for the Royal Festival Hall as part of the 1951 Festival of Britain. The Royal Festival Hall was the first post-war building to receive a Grade I listing. The building was designed by Leslie Martin, Peter Moro and Robert Matthews from London County Council's Architecture Department. According to Martin, 'The suspended auditorium provides the building with its major attributes: the great sense of space that is opened out within the building, the flowing circulation from the symmetrically placed staircases and galleries that became known as the "egg in the box".' (Historic England Archive; © Historic England Archive)

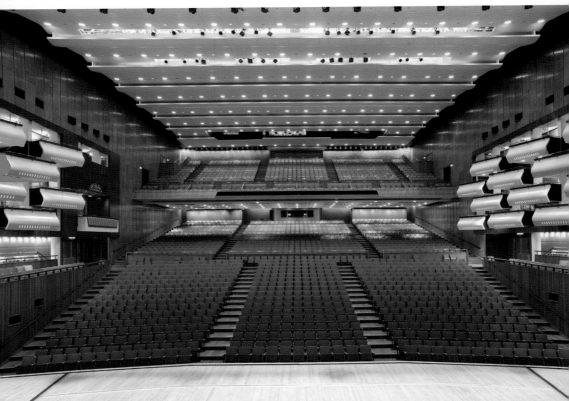

Hungerford Bridge

Isambard Kingdom Brunel's Hungerford Bridge was a suspension bridge originally designed for pedestrians and later converted for railway use before being replaced (not long after its original construction) by the still extant Charing Cross Railway Bridge. The chains of the demolished Hungerford suspension bridge were reused in the construction of Brunel's famous Clifton Suspension Bridge. This image dates from 1864 or earlier.

Waterloo Station

Waterloo is the UK's busiest and largest railway station. It has twenty-four platforms and covers an area of almost 100,000 square metres (24.5 acres). It was designed by William Tite for the London & South Western Railway, and opened in 1848 as Waterloo Bridge station. Combined with the Underground and Waterloo East stations, it is one of the busiest station complexes in Europe. The main concourse of the station is raised high above the ground by a complex of arches and tunnels.

Waterloo was a major terminal station for soldiers during the First World War, and so it was appropriate that when the station was rebuilt in the early twentieth century, the Victory Arch was included over the main entrance. Built of Portland stone by the little-known sculptor Charles Whiffen, bronze plaques bear the names of the 585 railway employees who were killed during the war. The arch is flanked by the sculptures of two Roman goddesses, Bellona and Pax, representing the beginning and end of the war. (Historic England Archive; © Historic England Archive)

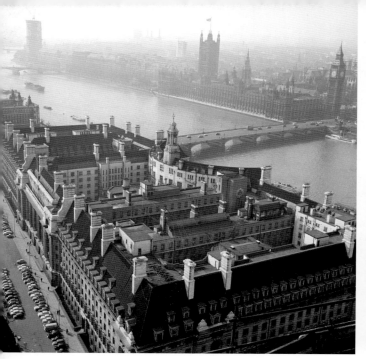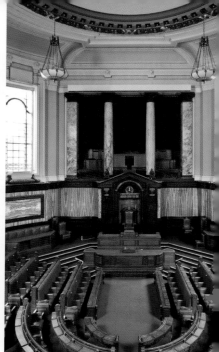

Above left and right: County Hall

The main six-storey building is faced in Portland stone in an Edwardian baroque style. Designed by architect Ralph Knott, it was officially opened by George V and Queen Mary in 1922, and for the next sixty-four years County Hall was the headquarters of local government for London. The north and south blocks were added between 1936 and 1939, but the Island block was not completed until 1974.

The octagonal Council Chamber at the centre of County Hall provided seating for over 200 council members, with four galleries for the public and members of the press. The Greater London Council was abolished in 1986 and today County Hall is home to various entertainment businesses and attractions. (© Historic England Archive; © Historic England Archive)

Opposite above: London Eye and County Hall

When the London Eye opened to the public in 2000 it was the world's tallest Ferris wheel, and offered the highest public viewing point in London until it was superseded by the observation deck on the seventy-second floor of 'The Shard' in 2013. It remains the tallest Ferris wheel in Europe and is the most popular paid tourist attraction in the UK with over 3.75 million visitors annually. Standing 135 metres (443 feet) tall, the wheel carries thirty-two passenger capsules, each representing one of the London boroughs. The wheel rotates at just under 1 km per hour (0.6 mph), taking around thirty minutes to make one revolution. (Author's collection)

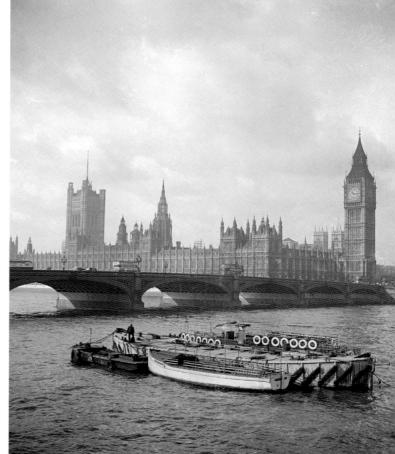

Westminster Bridge and the
Houses of Parliament
A boat on the River Thames
with the Westmnister Bridge
and the Houses of Parliament
in the background. (© Historic
England Archive)

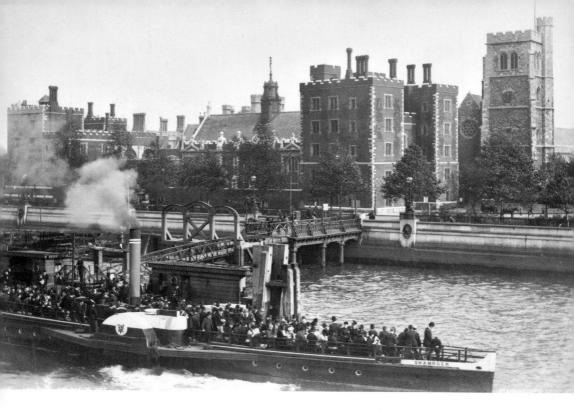

Above: Lambeth Palace

Standing opposite the Palace of Westminster, Lambeth Palace has been the official London residence of the Archbishop of Canterbury for 800 years. The impressive red-brick Tudor gatehouse was built in 1490 by Cardinal John Morton, after whom it is named. The oldest surviving part is the Crypt Chapel, which was originally used for storage and only became a chapel in the Second World War when the main chapel was badly damaged. The latter has been the Archbishop of Canterbury's private chapel since the thirteenth century, although the ceiling artwork by Leonard Henry Rosoman dates back only to 1988. The Great Hall is also early thirteenth century and is where the archbishop would receive and entertain important guests, including royalty. However, after it was ransacked and demolished by Cromwell's troops during the English Civil War, Archbishop William Juxon had it completely rebuilt in 1663 with a late Gothic hammer-beam roof. Today the Great Hall is part of Lambeth Palace Library and houses over 120,000 books as well as the archives of the Archbishops of Canterbury and other church bodies dating back to the twelfth century. (Historic England Archive)

Opposite above: No. 85 Albert Embankment, Vauxhall Cross

No. 85 Albert Embankment at Vauxhall Cross is the headquarters of the British Secret Intelligence Service (popularly known as MI6), the UK's foreign intelligence agency. It is rumoured to be referred to within the intelligence community as 'Babylon-on-Thames' because of its resemblance to an ancient Mesopotamian ziggurat. In fact, the design by architect Terry Farrell was influenced in part by Mayan and Aztec religious temples. The multistorey building has sixty separate roof areas and uses twenty-five different types of glass. The windows are triple glazed for security purposes and successfully thwarted a rocket attack in 2000. The building fared less well in the twenty-third James Bond film *Skyfall*, in which it was fictitiously destroyed. (© Historic England Archive. John Laing Collection)

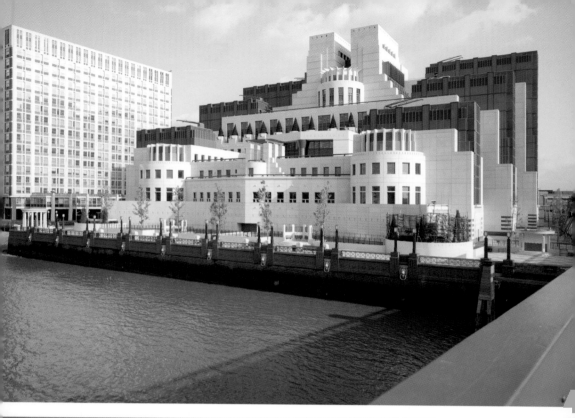

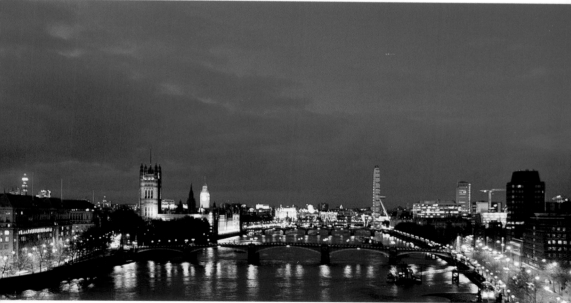

Lambeth
A night-time view of Lambeth, across the river from Westminster, on the left-hand side. Lambeth
Bridge is in the foreground. (Author's collection)

About the Archive

Many of the images in this volume come from the Historic England Archive, which holds over 12 million photographs, drawings, plans and documents covering England's archaeology, architecture, social and local history.

The photographic collections include prints from the earliest days of photography to today's high-resolution digital images. Subjects range from Neolithic flint mines and medieval churches to art deco cinemas and 1980s shopping centres. The collection is a vivid record both of buildings that are still part of everyday life – places of work, leisure and worship – and those lost long ago, surviving only in fragile prints or glass-plate negatives.

Six million aerial photographs offer a unique and fascinating view of the transformation of England's towns, cities, coast and countryside from 1919 onwards. Highlights include the pioneering photography of Aerofilms, and the comprehensive survey of England captured by the RAF after the Second World War.

Plans, drawings and reports provide further context and reconstruction artworks bring archaeological sites and historic buildings to life.

The collections are housed in a purpose-built environmentally controlled store in Swindon, which provides the best conditions to preserve archive items for future generations to enjoy. You can search our catalogue online, see and buy copies of our images, as well as visiting our public search room by appointment.

Find out more about us at HistoricEngland.org.uk/Photos
email: archive@historicengland.org.uk
tel.: 01793 414600

The Historic England offices and archive store in Swindon from the air, 2007.